love between the lines

AN ADULT COLORING BOOK FOR BOOK LOVERS

CHRISTINA COLLIE

FOREVER

NEW YORK BOSTON

Forever
Hachette Book Group
1290 Avenue of the Americas, New York, NY 10104
forever-romance.com
twitter.com/foreverromance

First Edition: November 2016

Forever is an imprint of Grand Central Publishing. The Forever name and logo are trademarks of Hachette Book Group, Inc.

The publisher is not responsible for websites (or their content) that are not owned by the publisher.

The Hachette Speakers Bureau provides a wide range of authors for speaking events. To find out more, go to www.hachettespeakersbureau.com or call (866) 376-6591.

ISBN: 978-1-4555-9868-7 (trade pbk.)

Printed in the United States of America

Walsworth

0 9 8 7 6 5 4 3 2 1

This is dedicated to all the authors out there who pour their souls into words and sentences and paragraphs that form the most amazing stories. And for readers like me, who breathe in those words and fall into those books headfirst, kicking and screaming when it's time to leave.

"BOOKS ALLOW YOU
to be whoever
YOU WANT TO BE,
TO ESCAPE YOURSELF
for a while"

—MAKING FACES
BY AMY HARMON

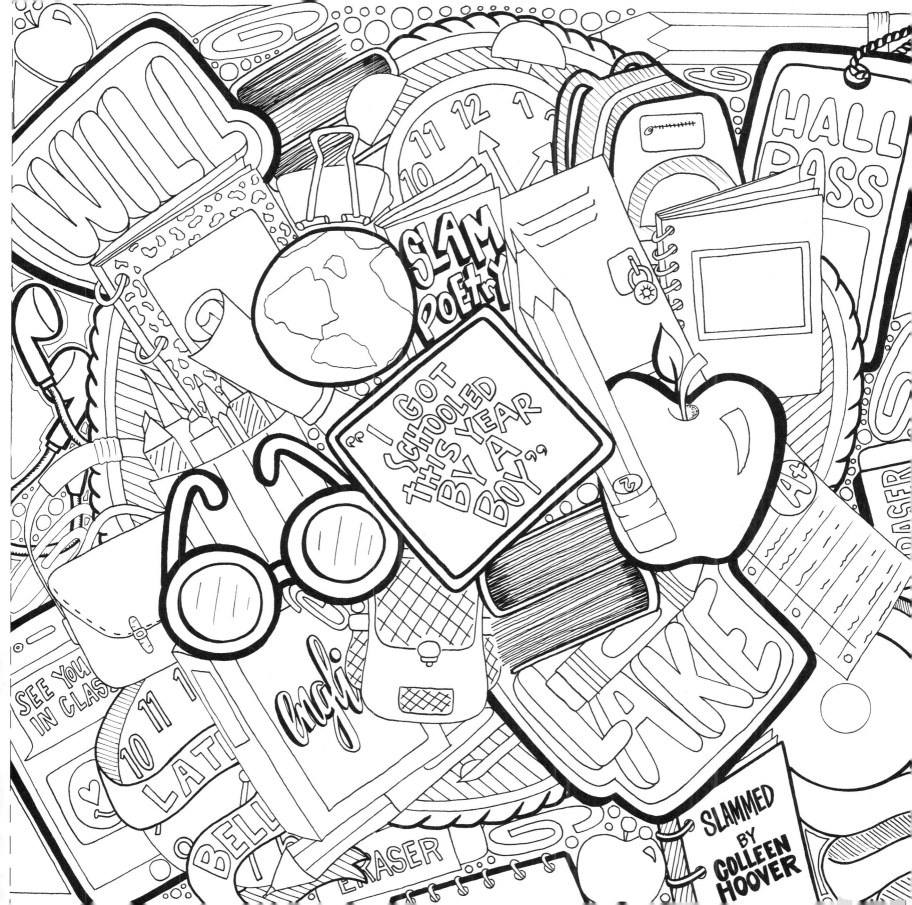

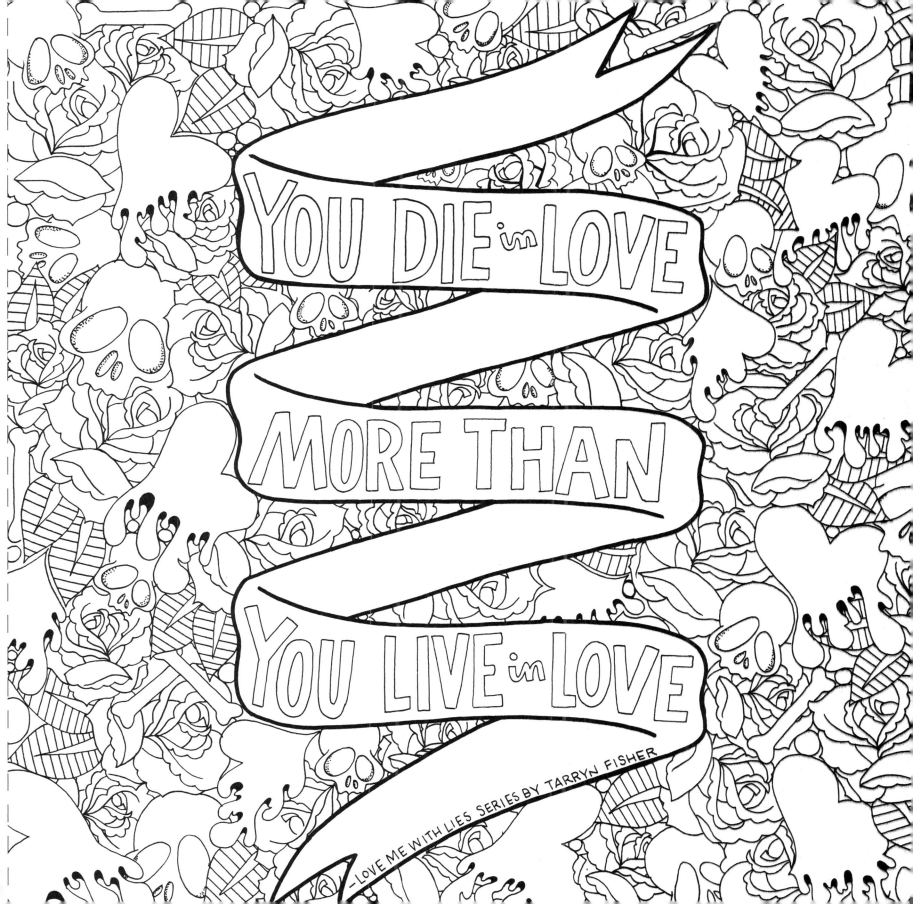

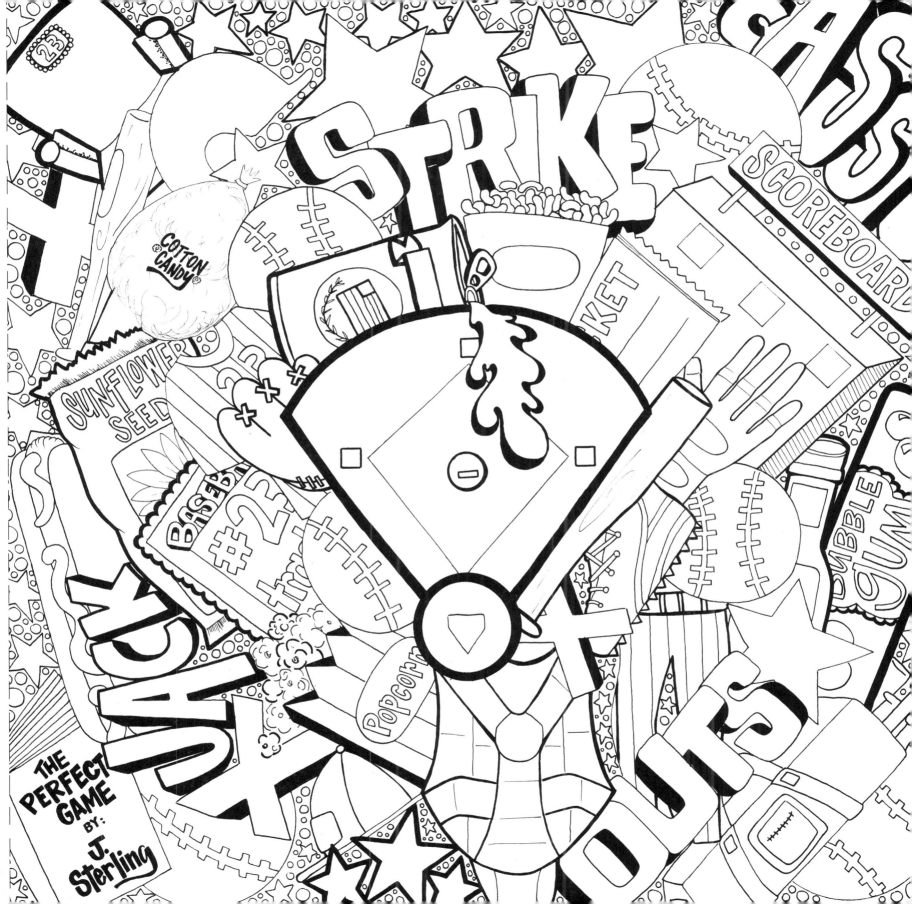

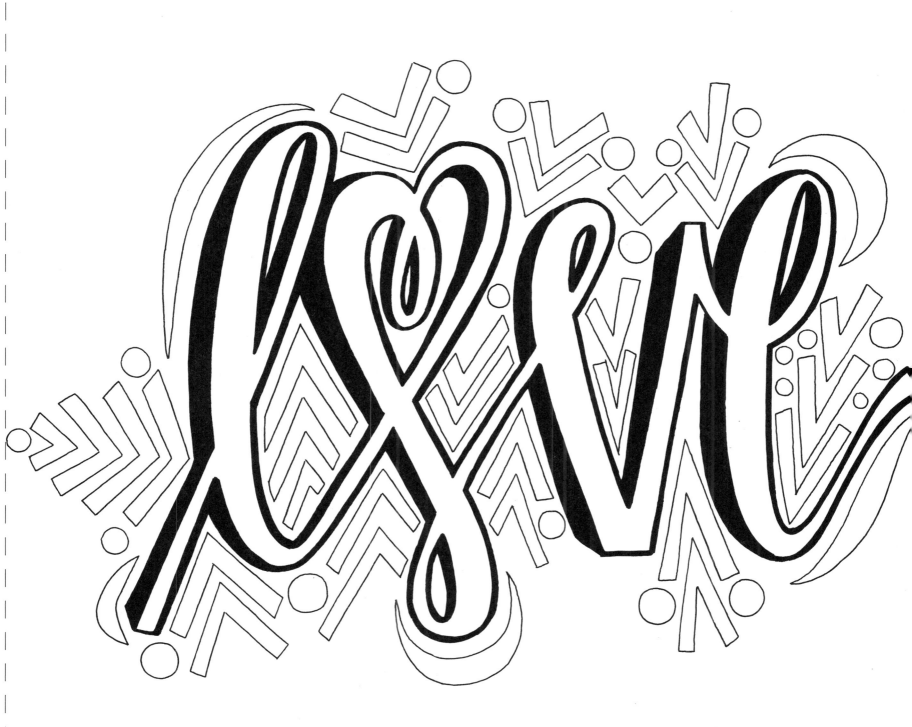

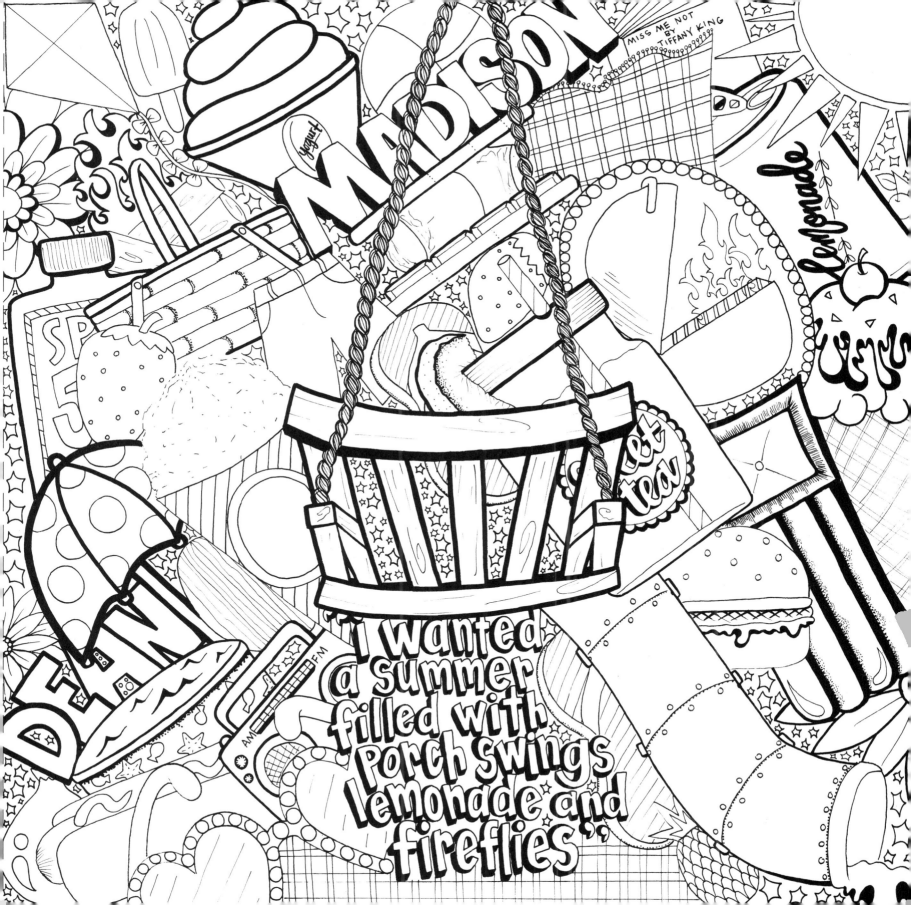

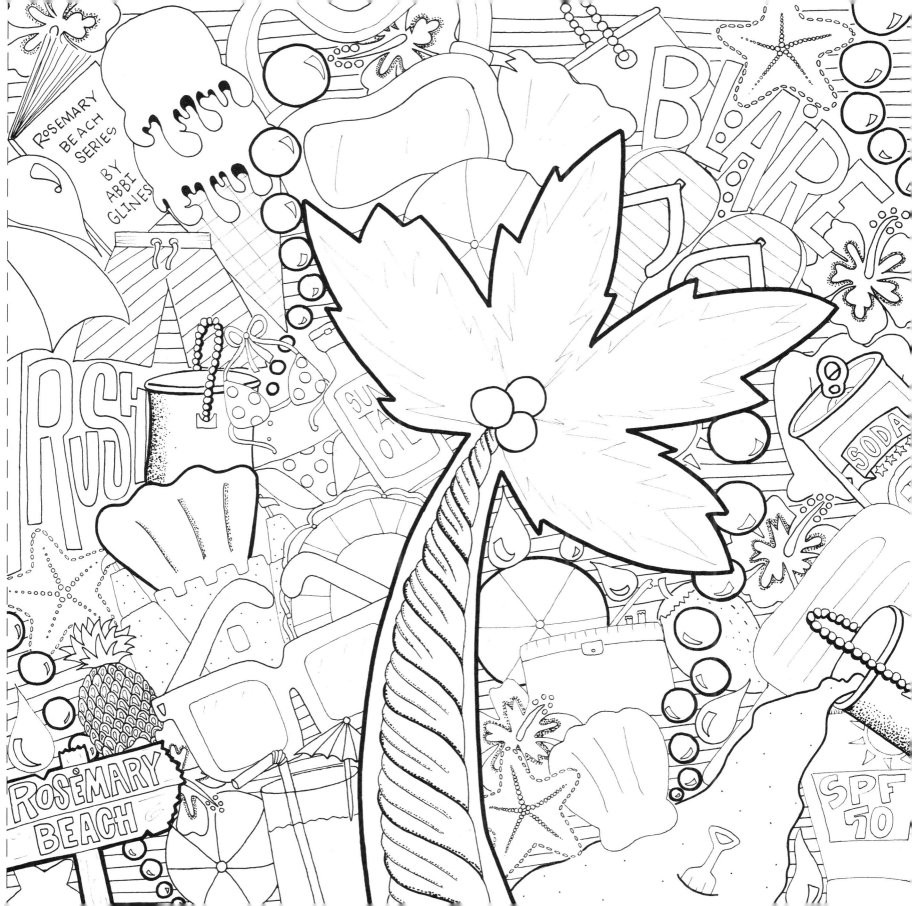

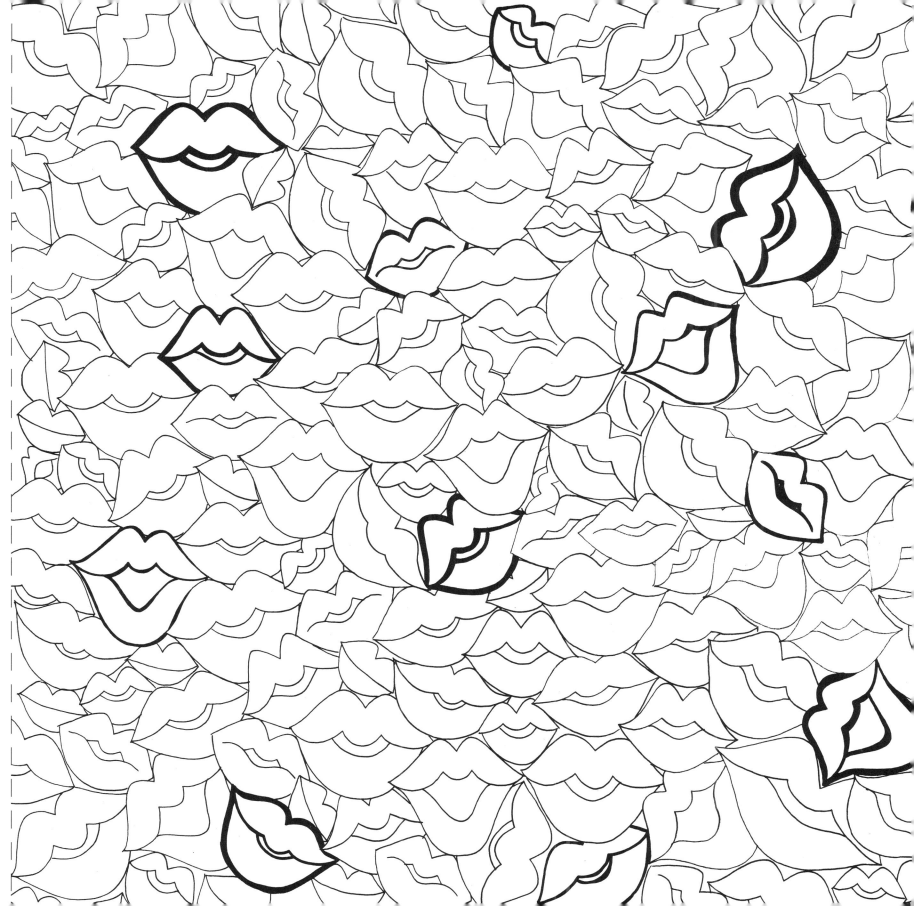

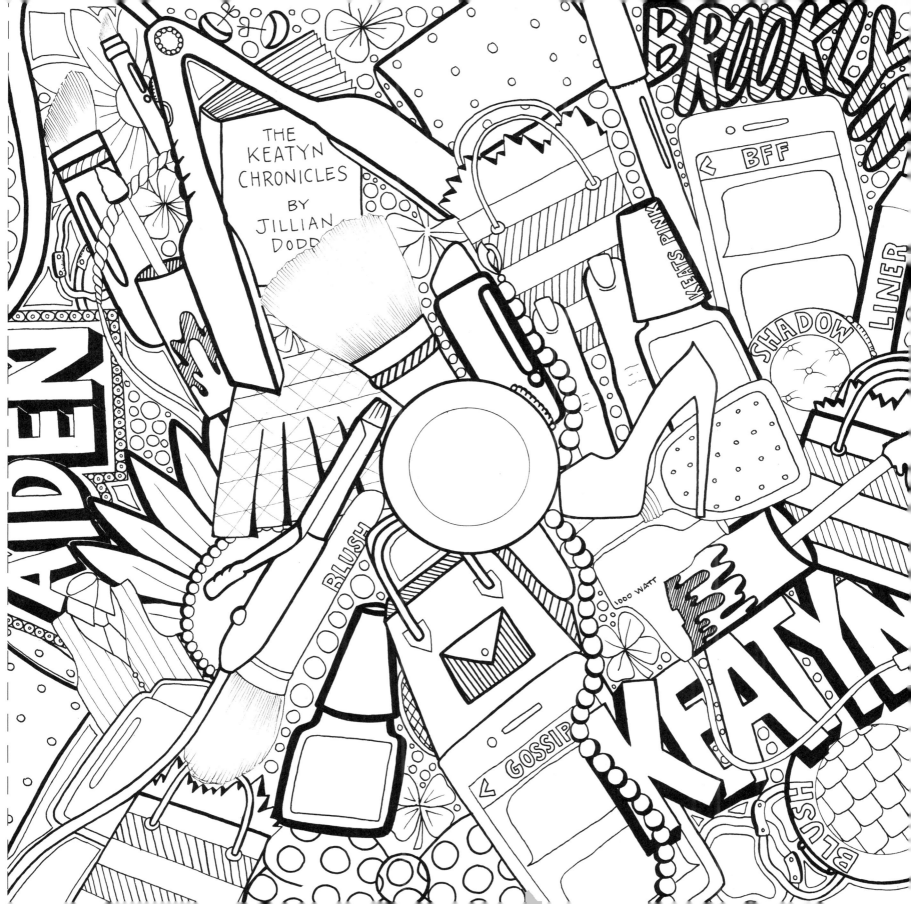

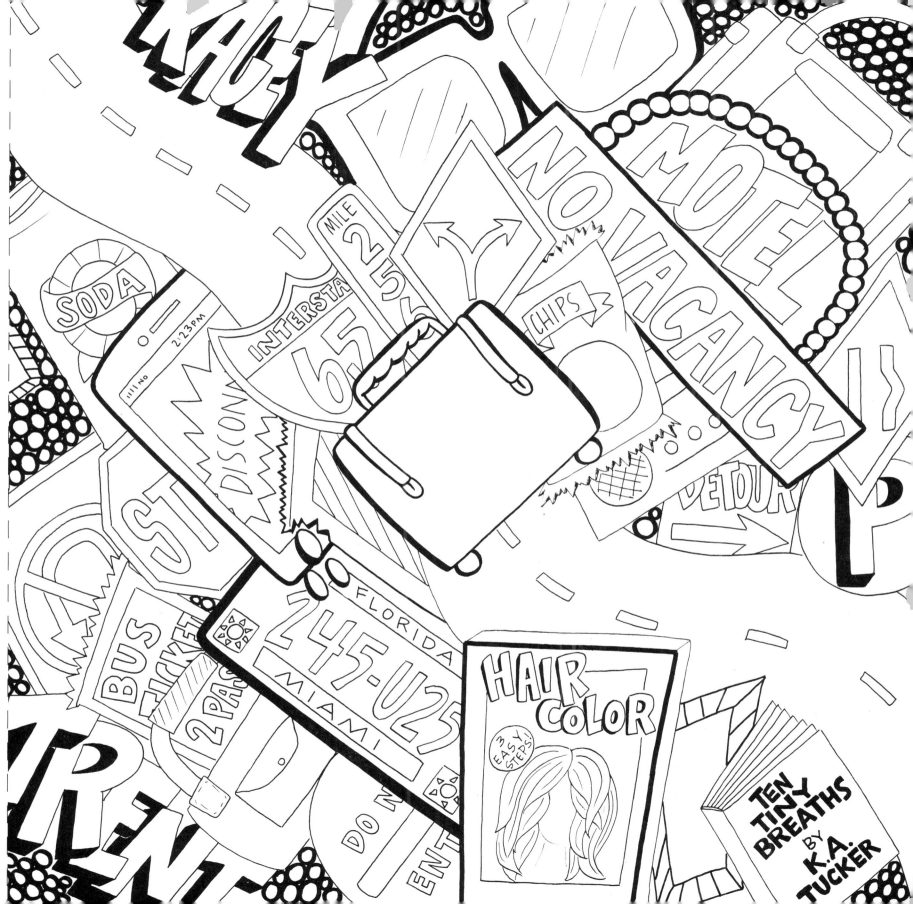

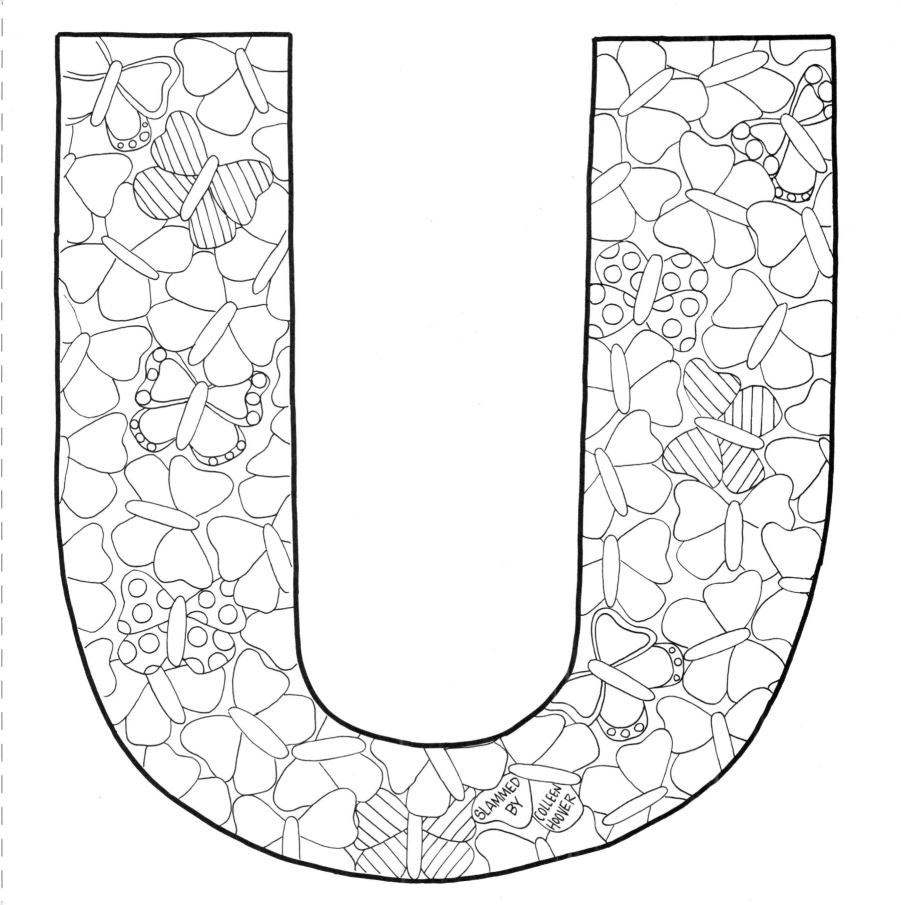

SLAMMED BY COLLEEN HOOVER

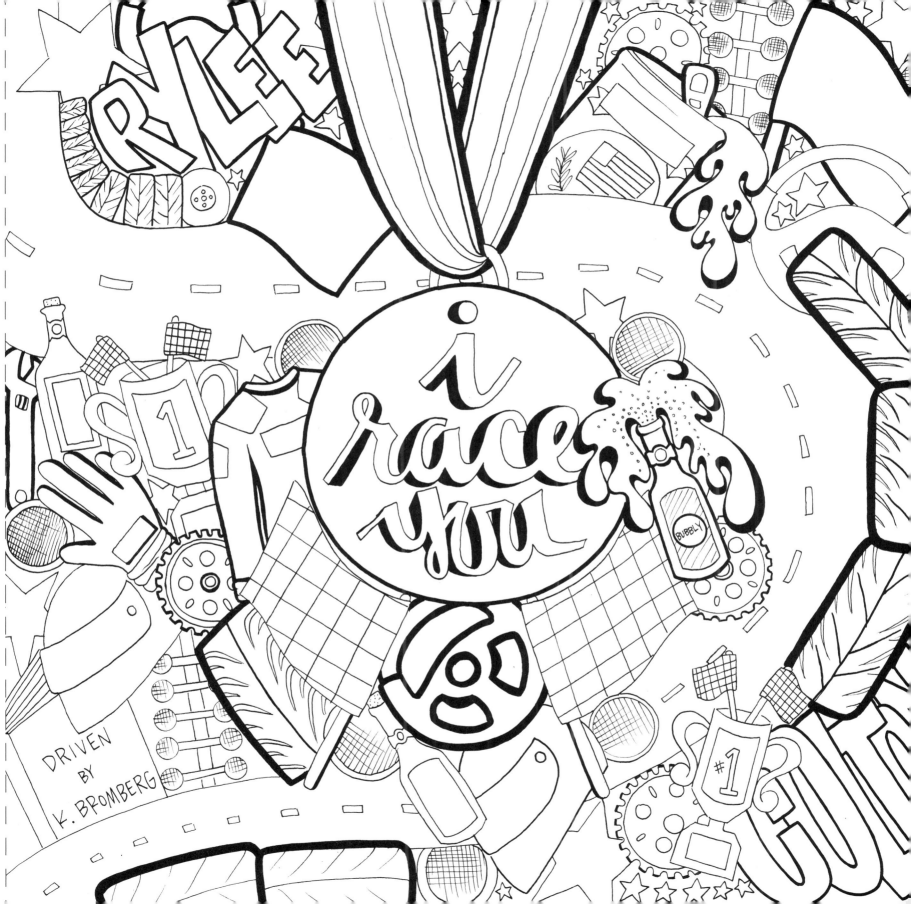

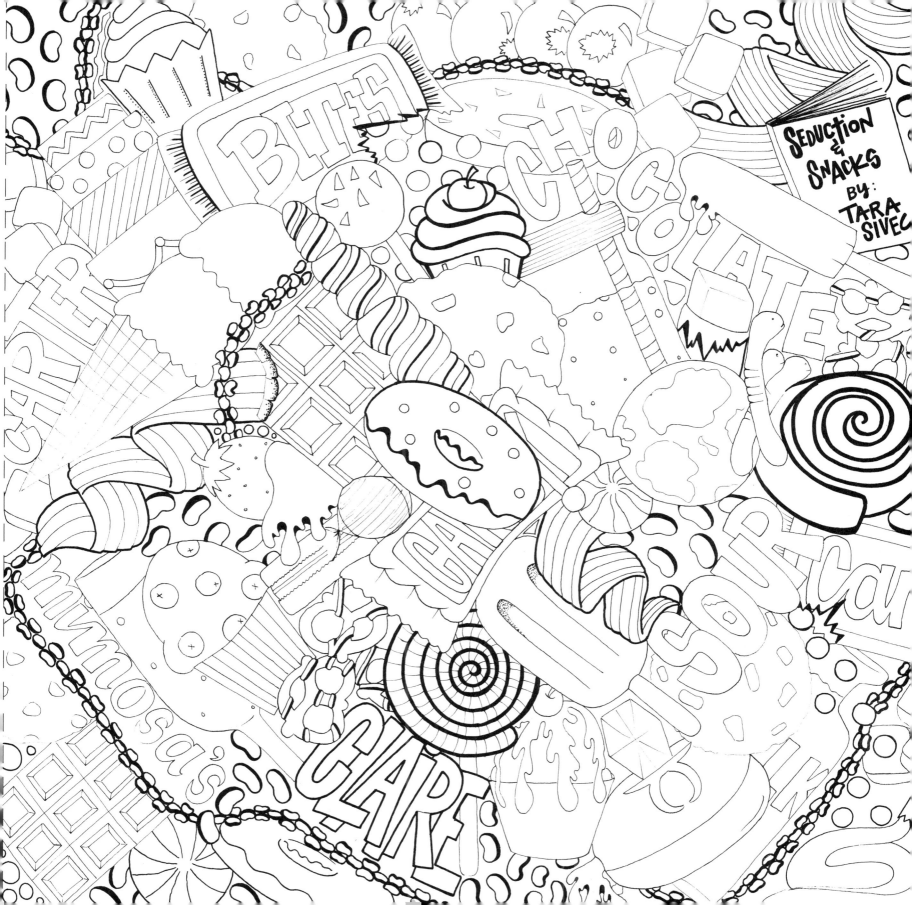

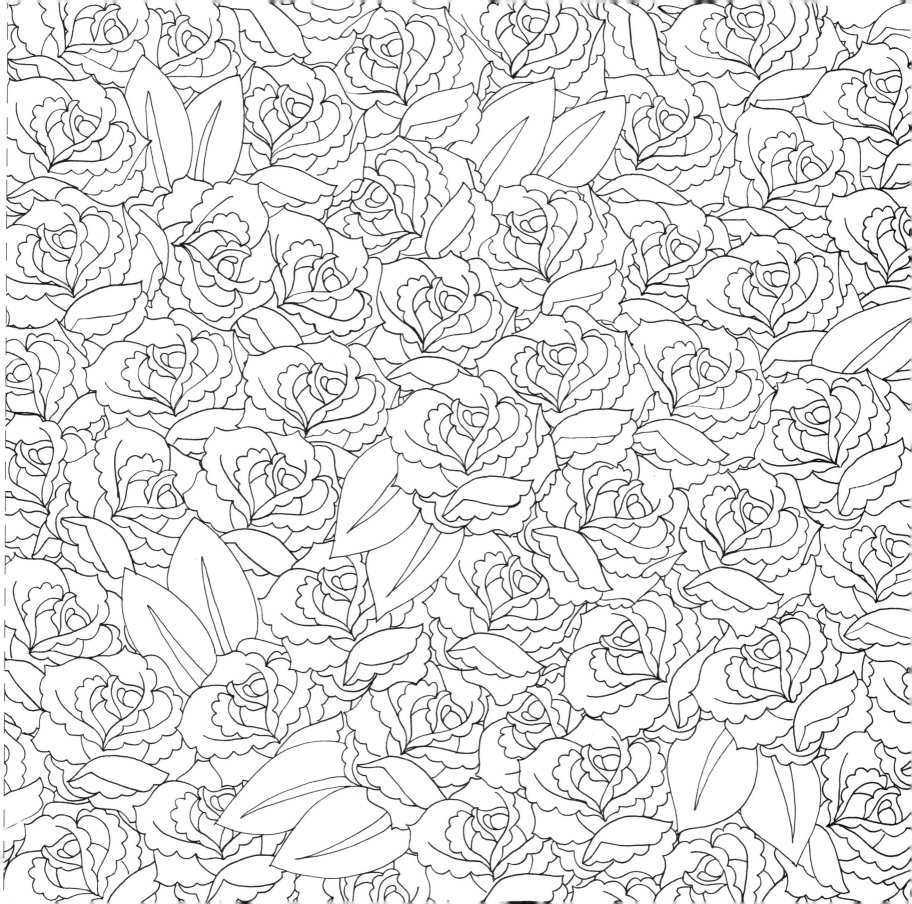

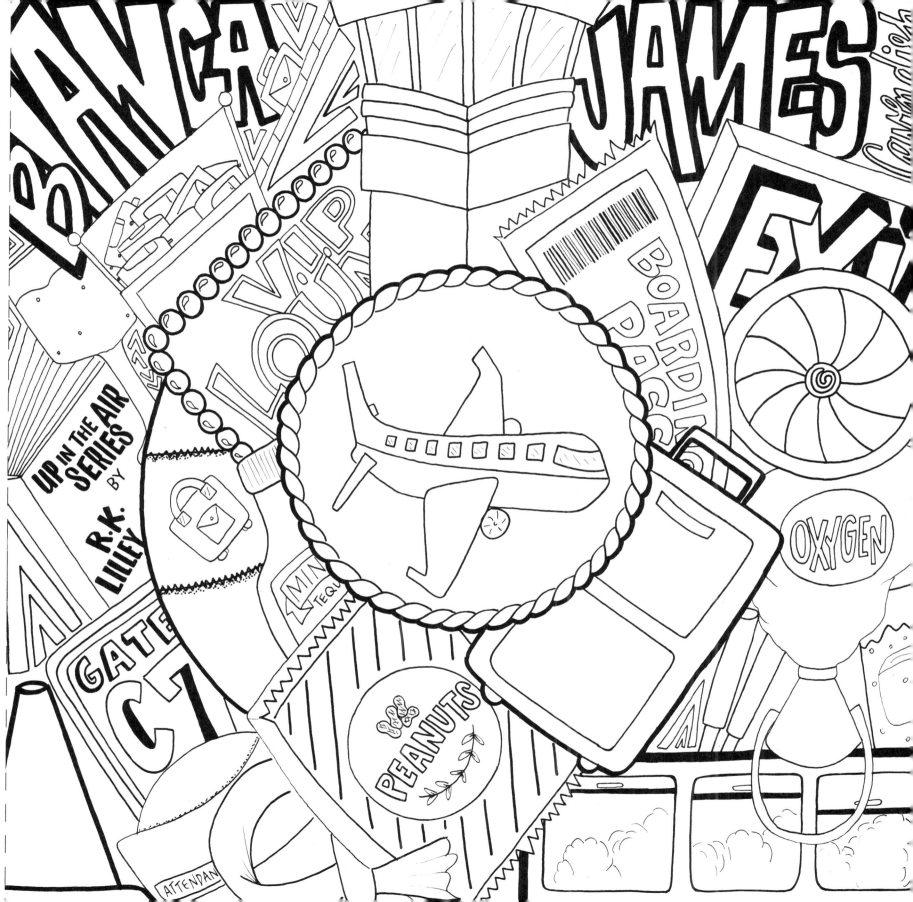

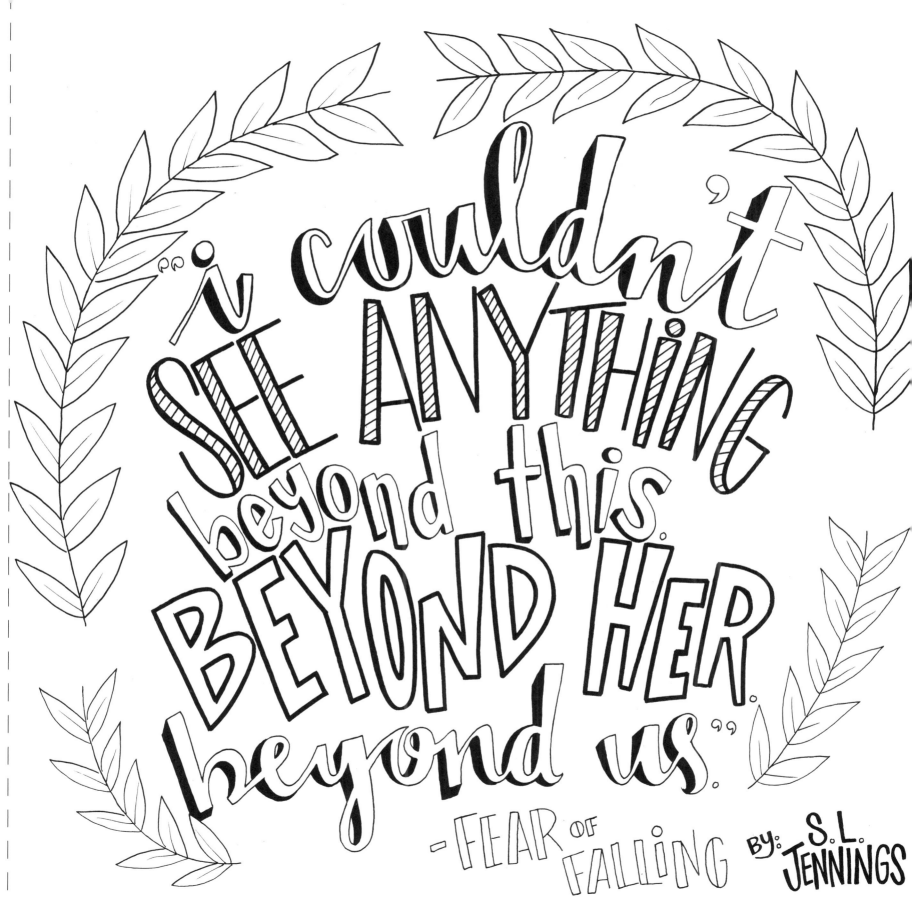

"i couldn't see anything beyond this. BEYOND HER. beyond us."

- FEAR OF FALLING BY: S.L. JENNINGS

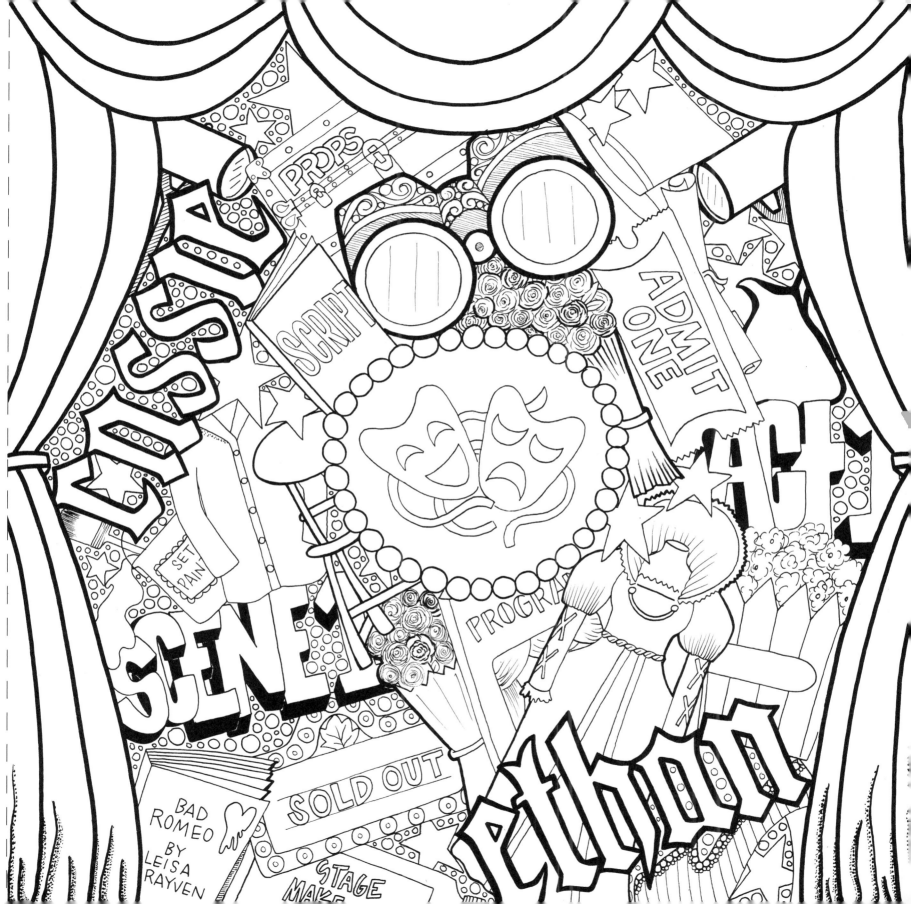

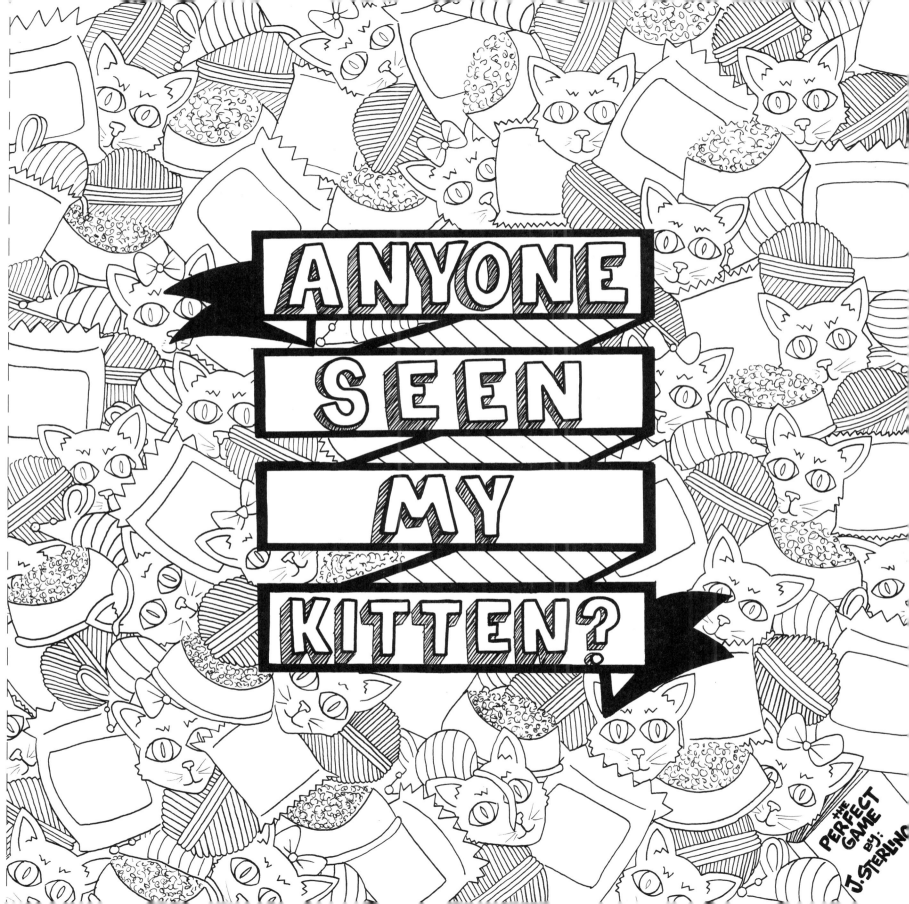

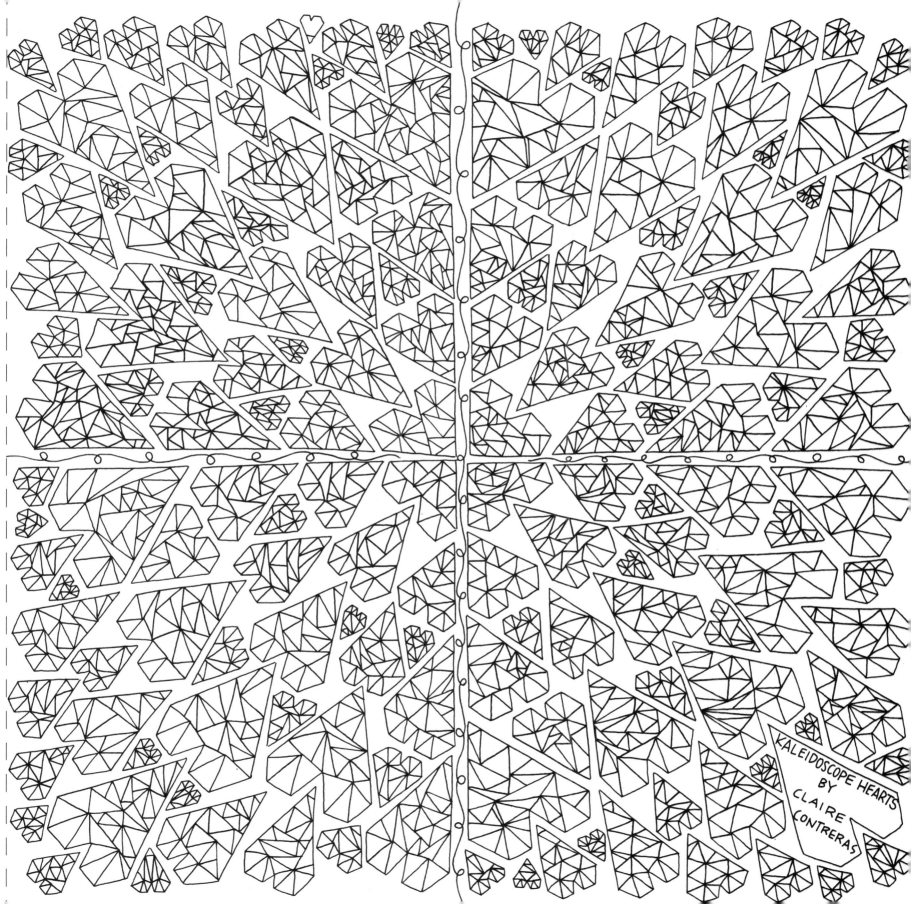

KALEIDOSCOPE HEARTS
BY
CLAIRE
CONTRERAS

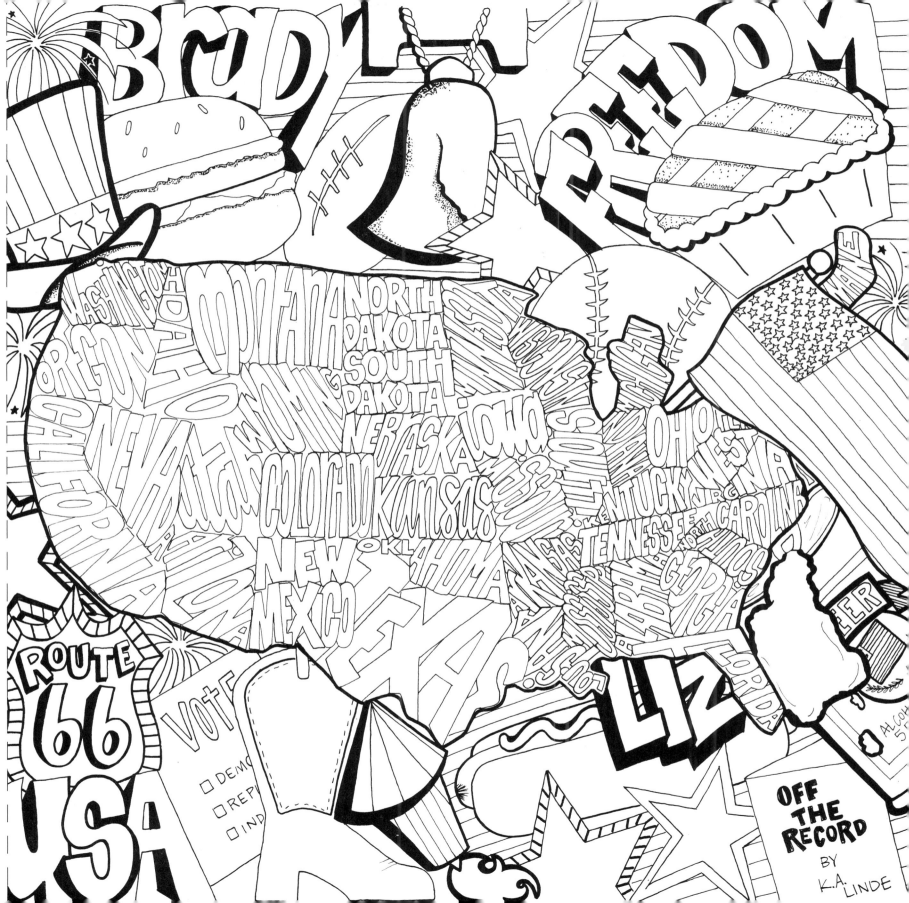

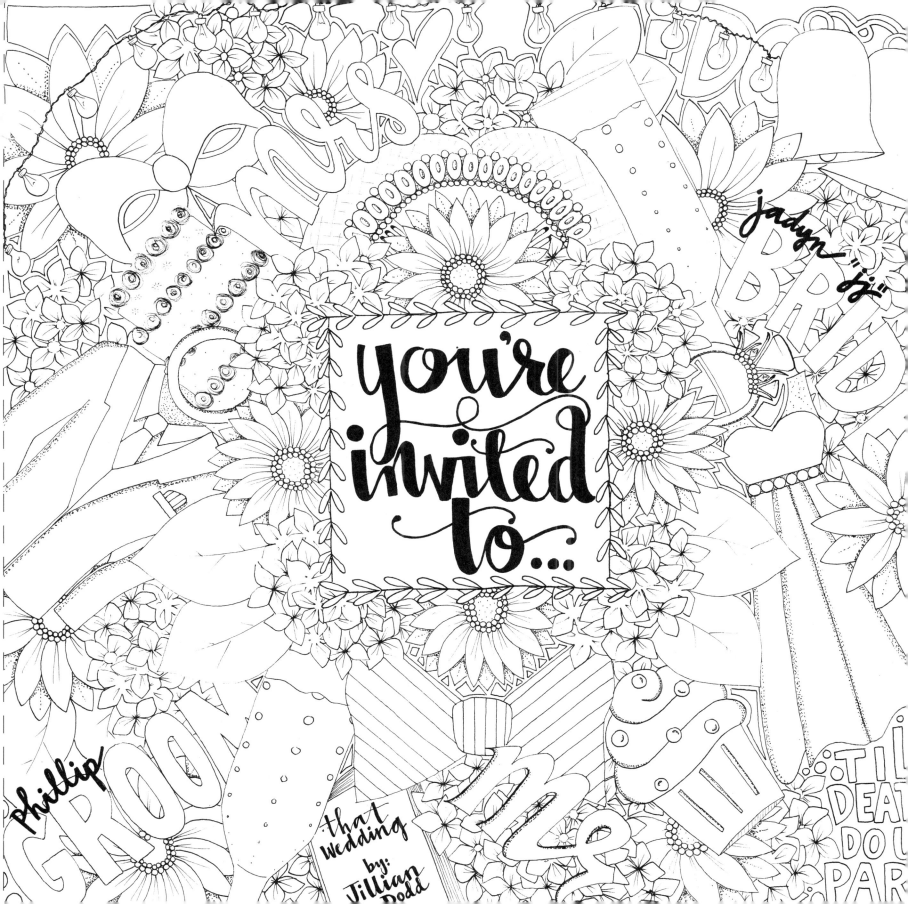

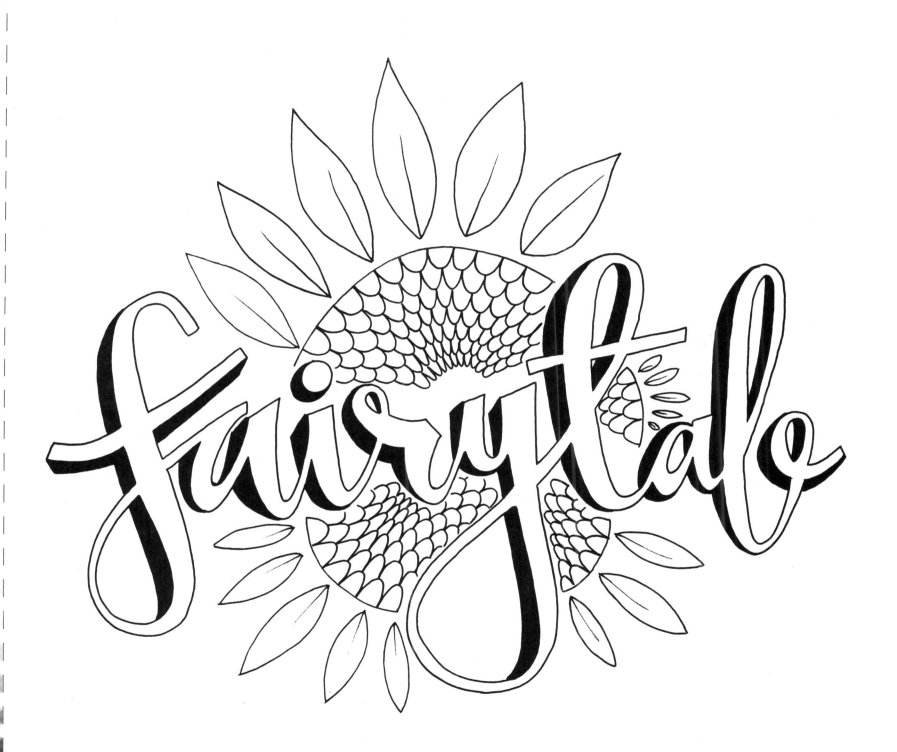

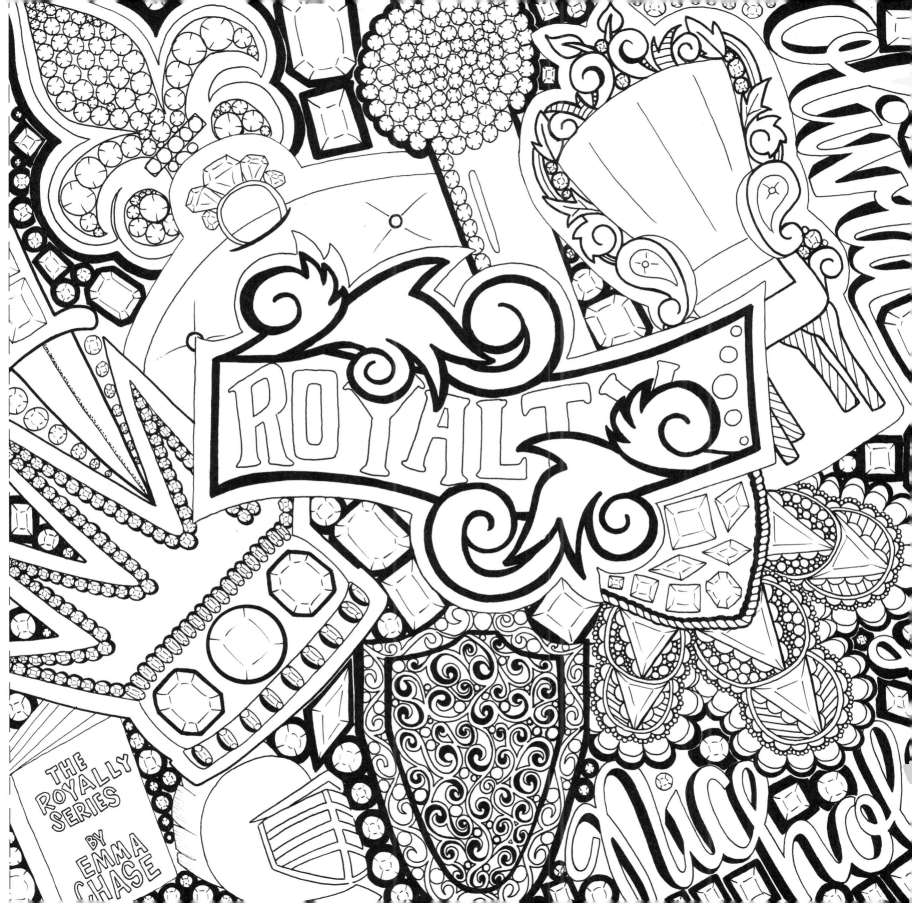

ROYALTY

THE ROYALLY SERIES BY EMMA CHASE

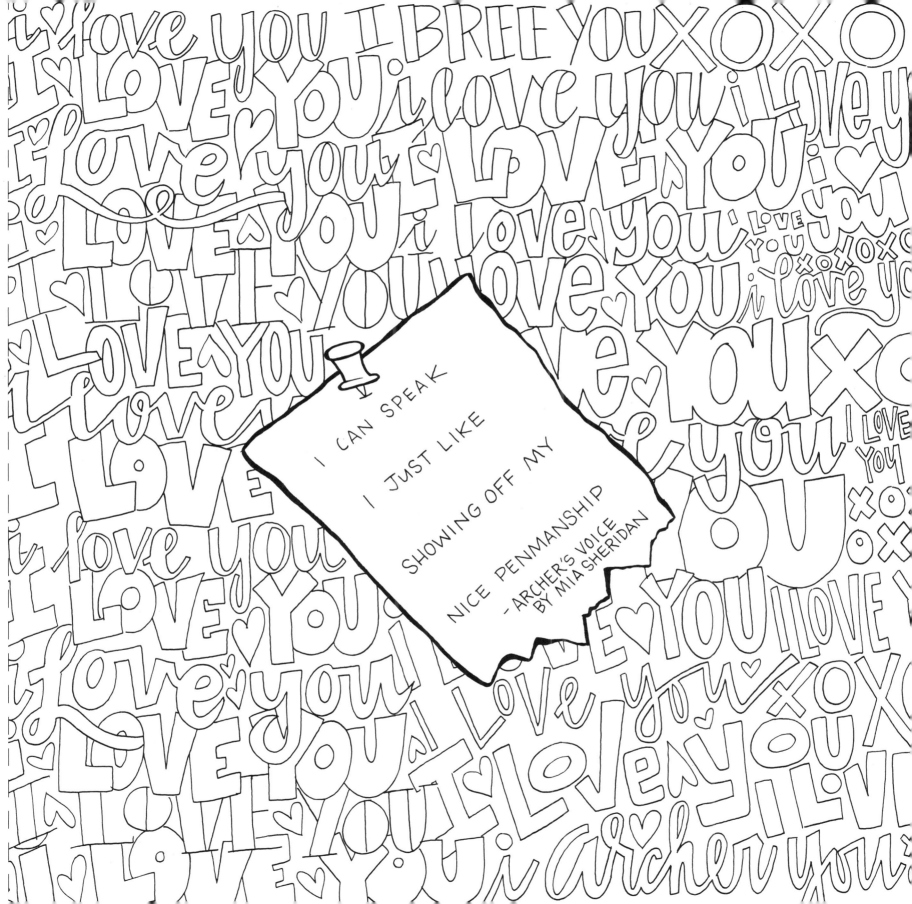

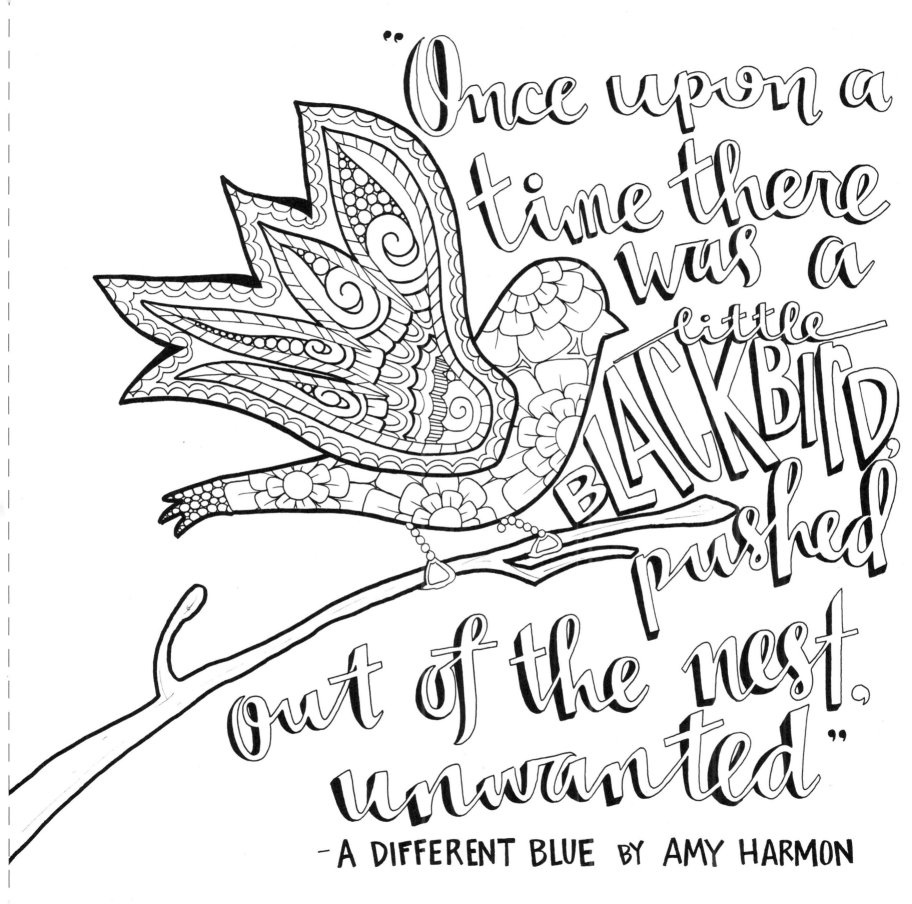

"Once upon a time there was a little BLACKBIRD, pushed out of the nest, unwanted"

—A DIFFERENT BLUE BY AMY HARMON

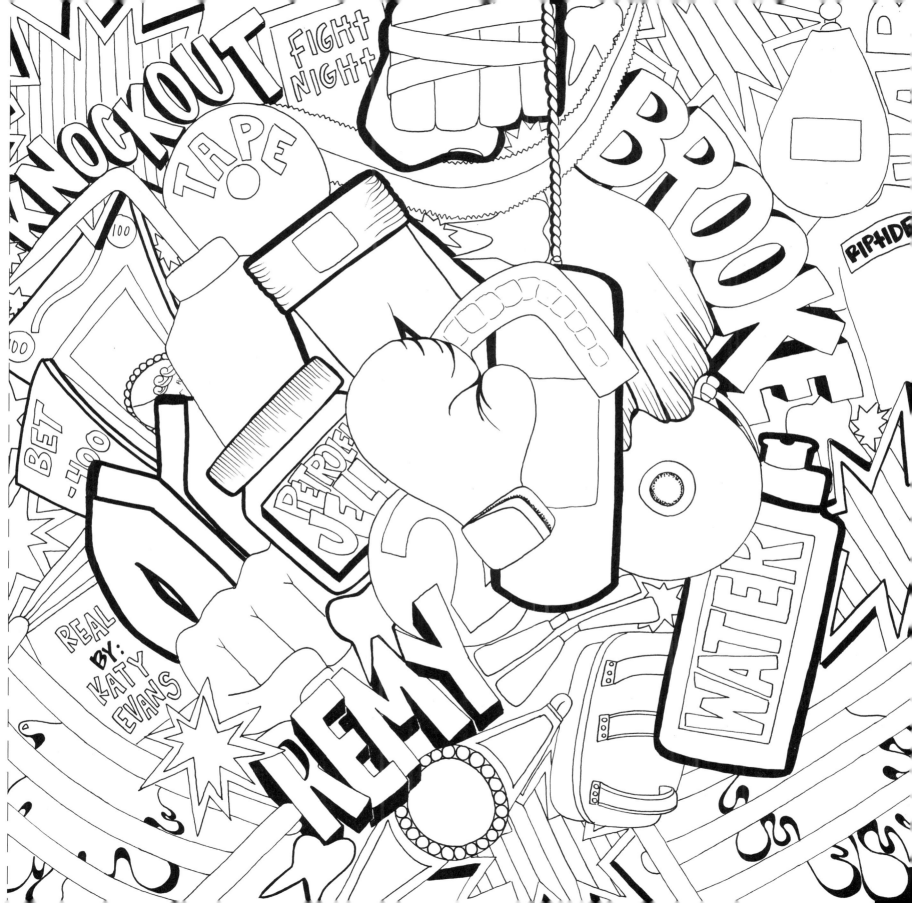

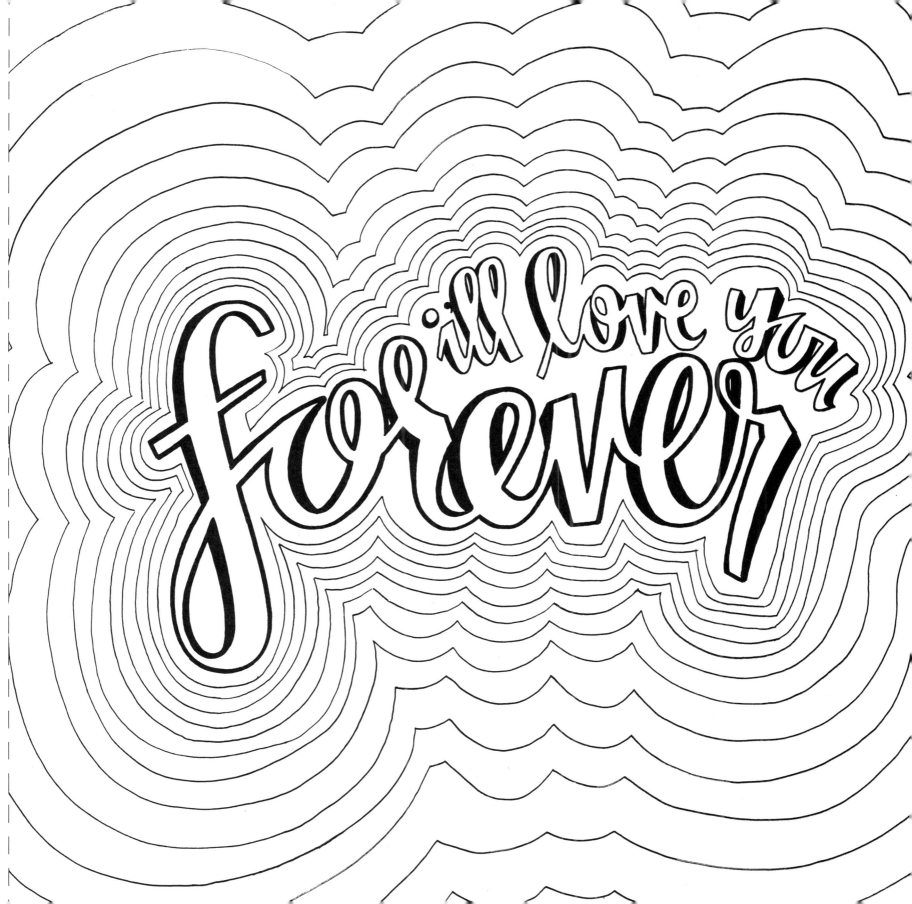

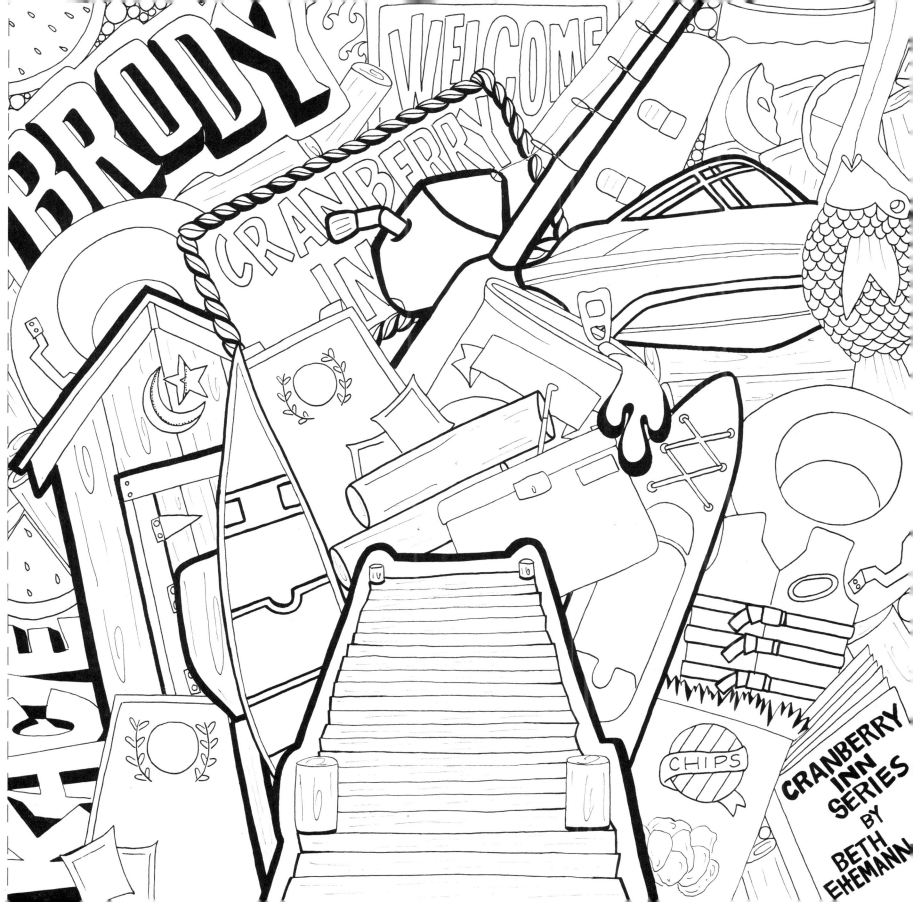

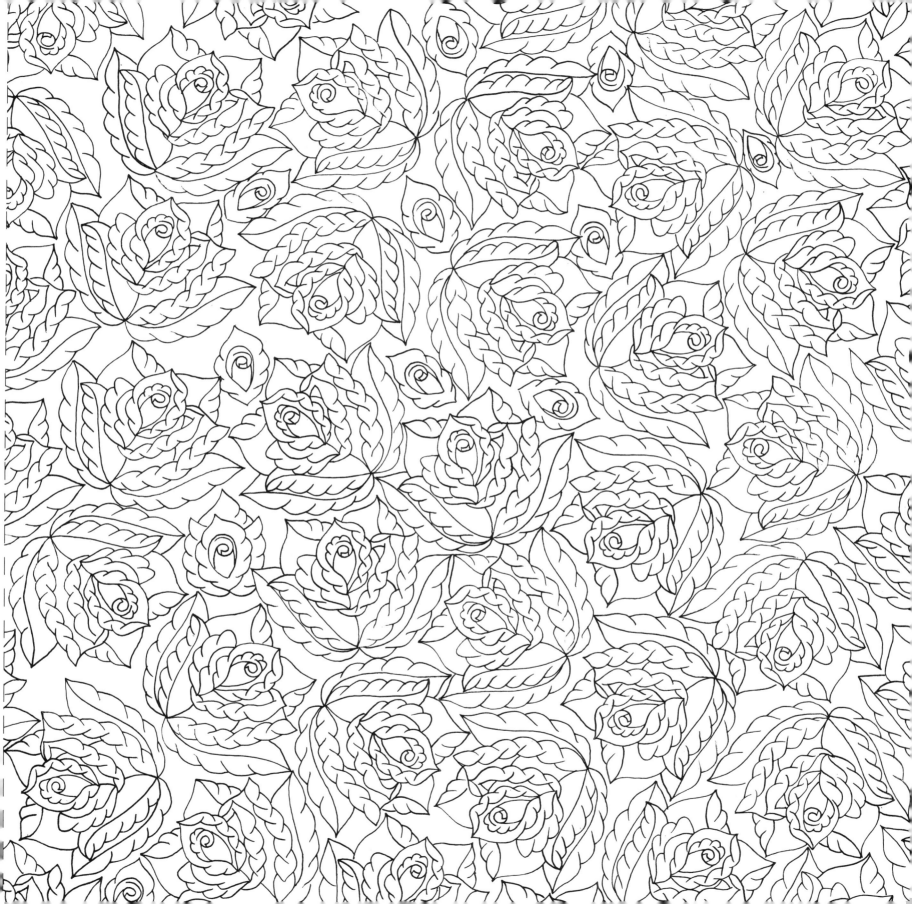

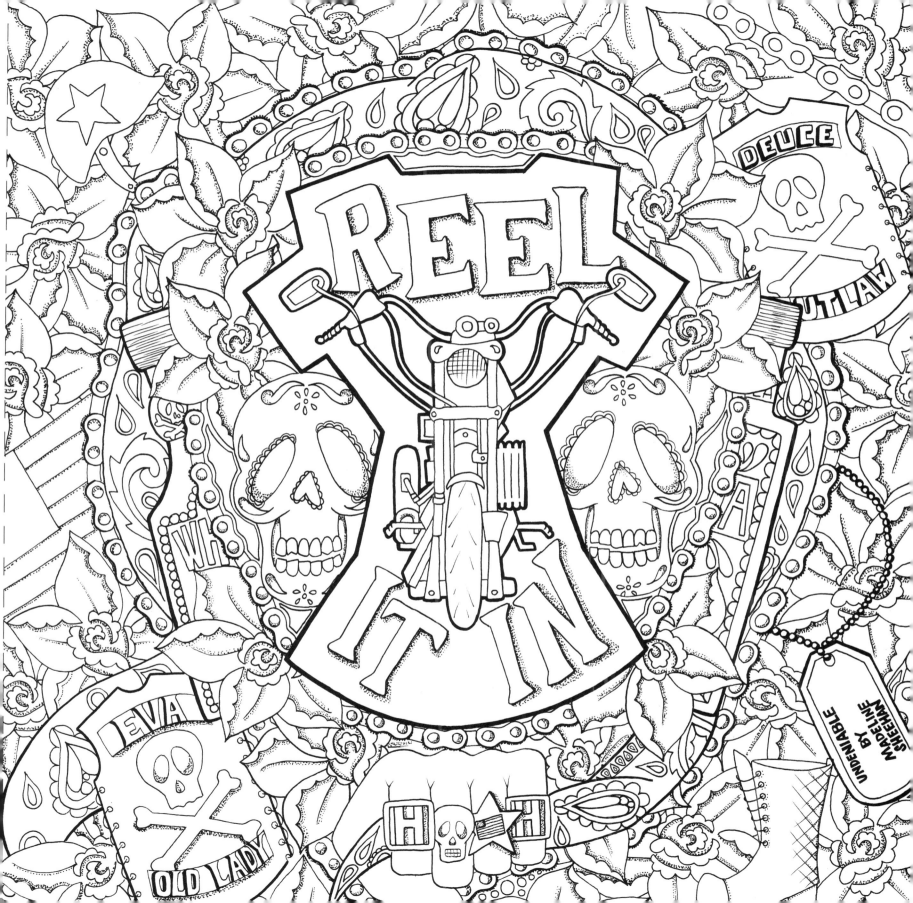

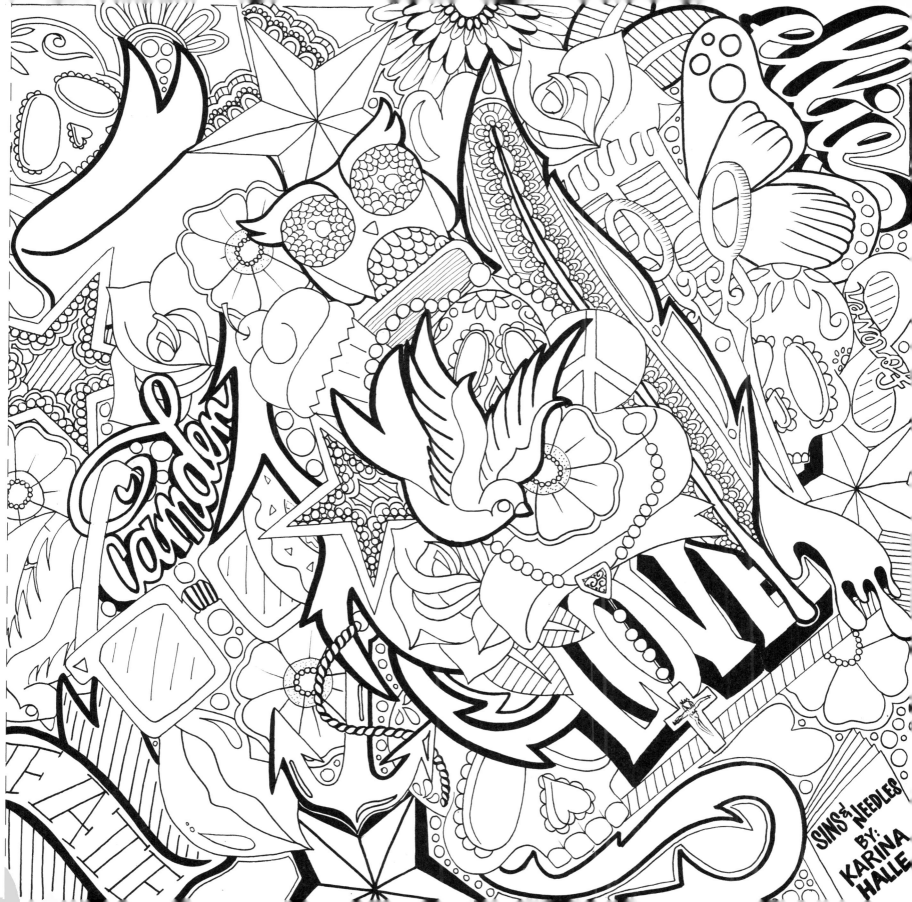

SINS & NEEDLES
BY:
KARINA HALLE

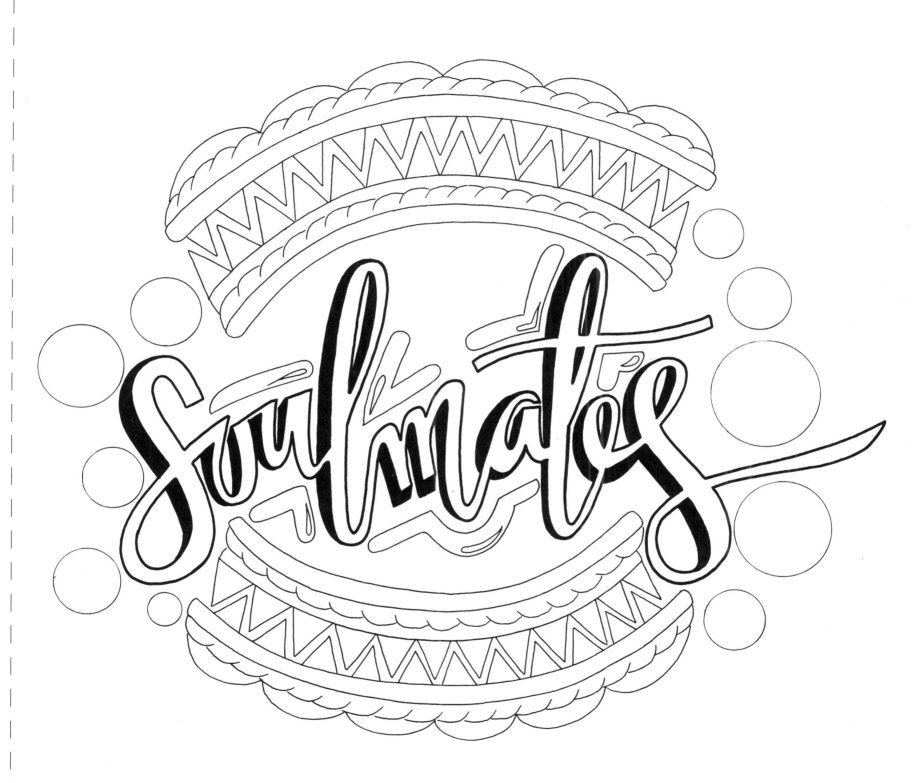

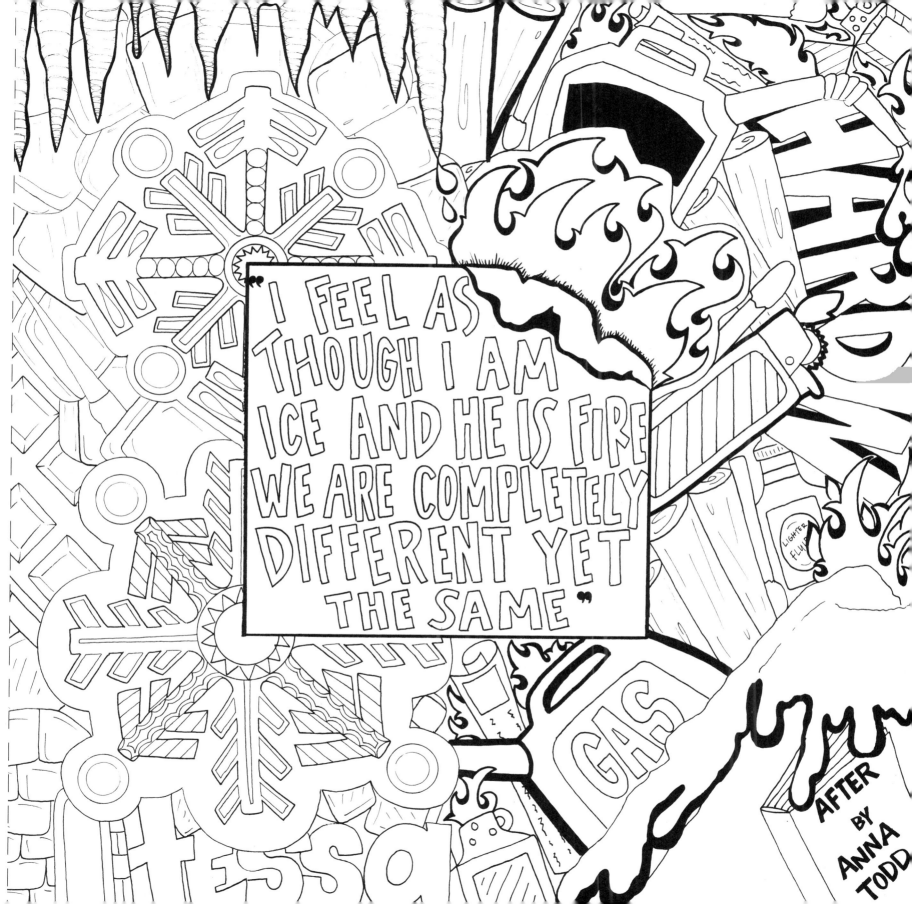

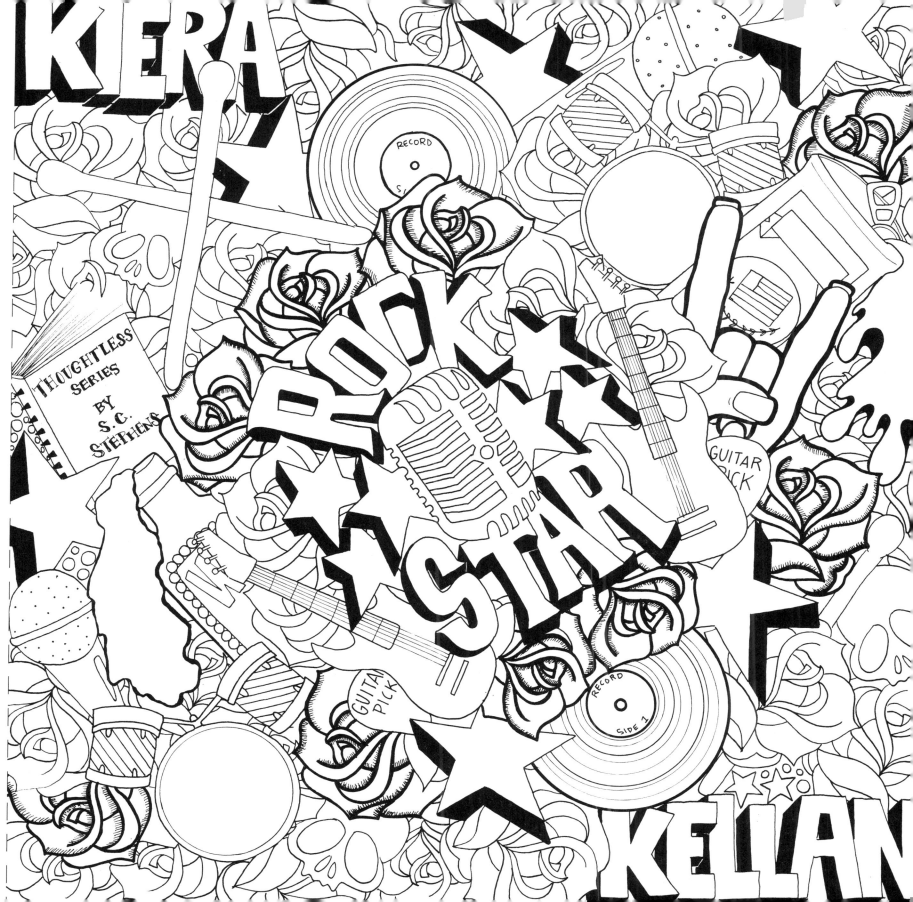

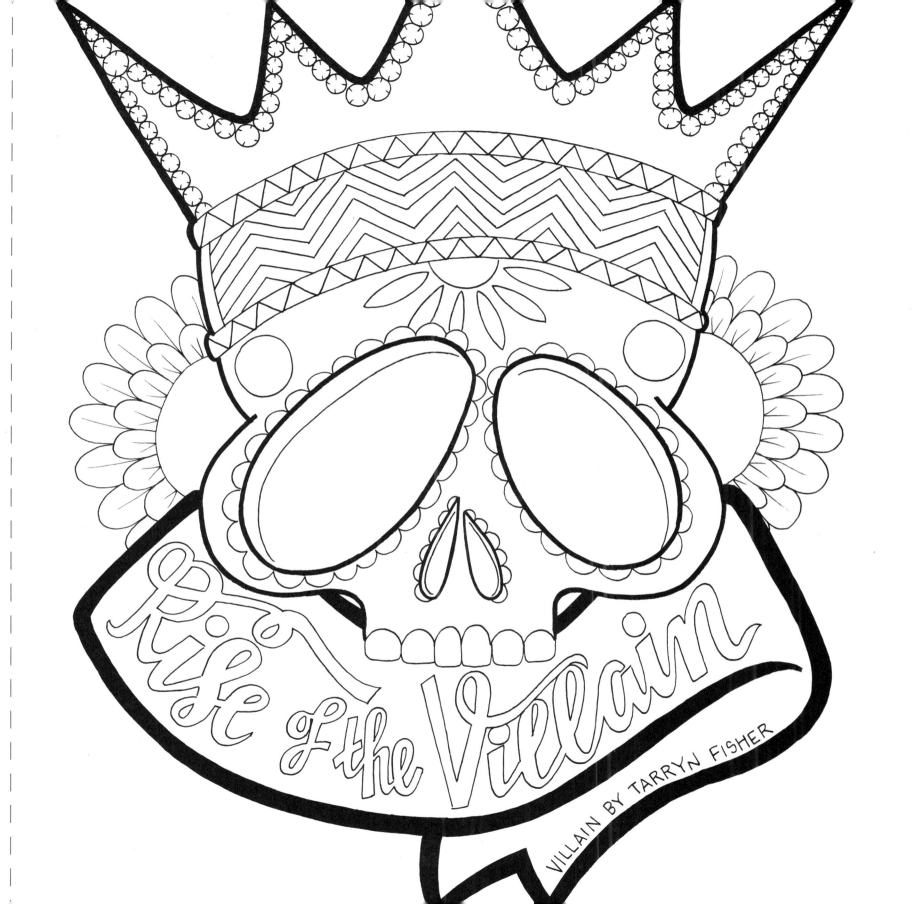

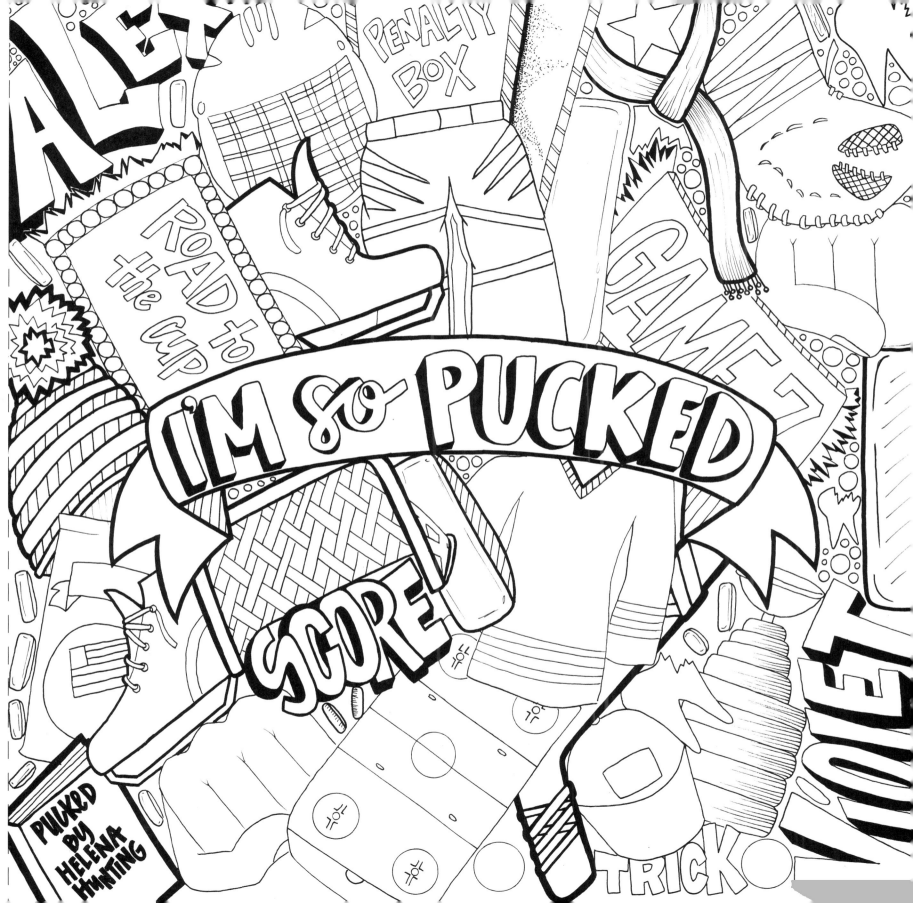

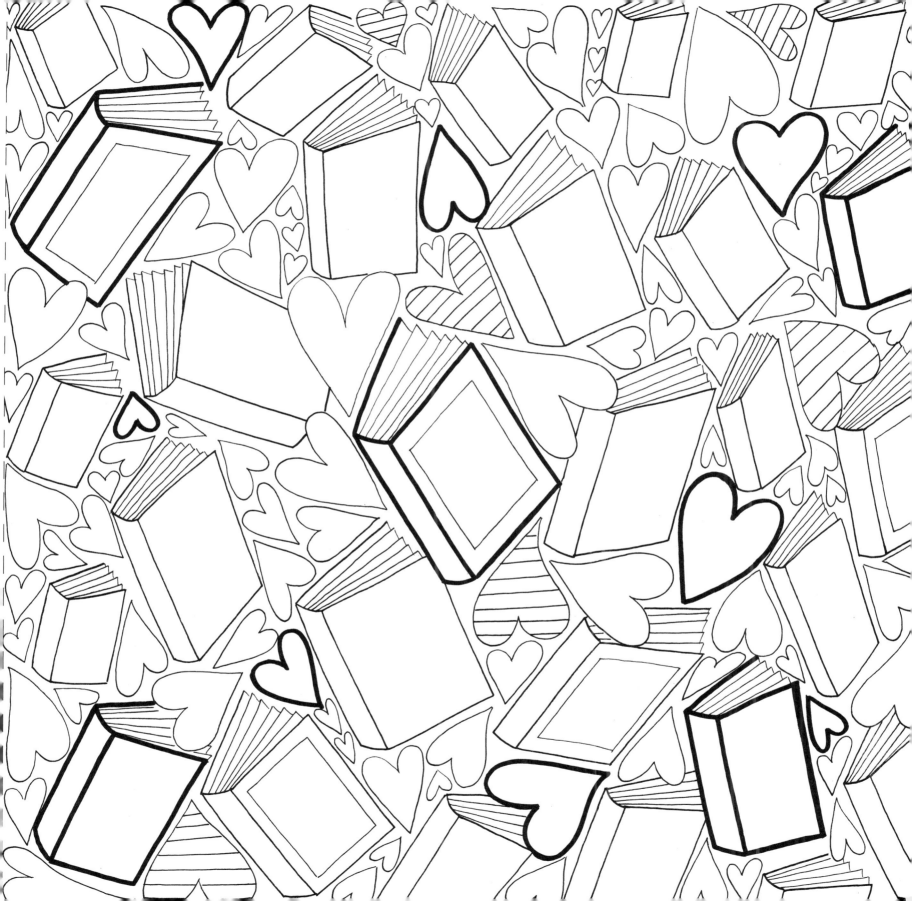

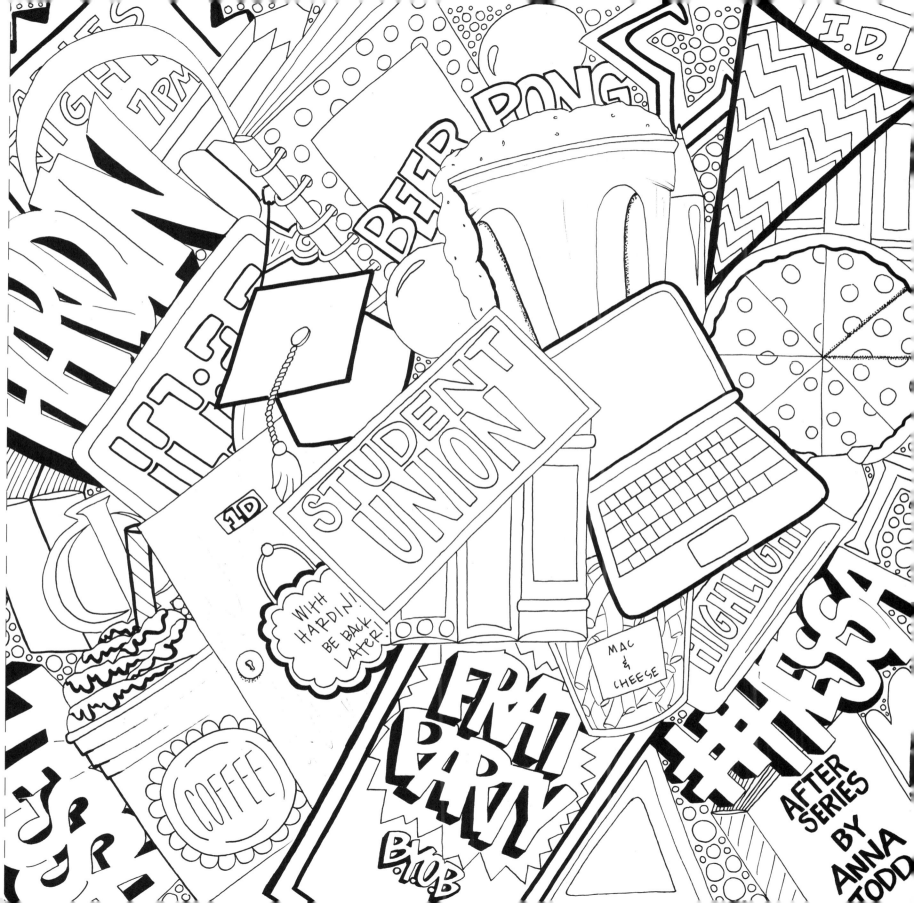

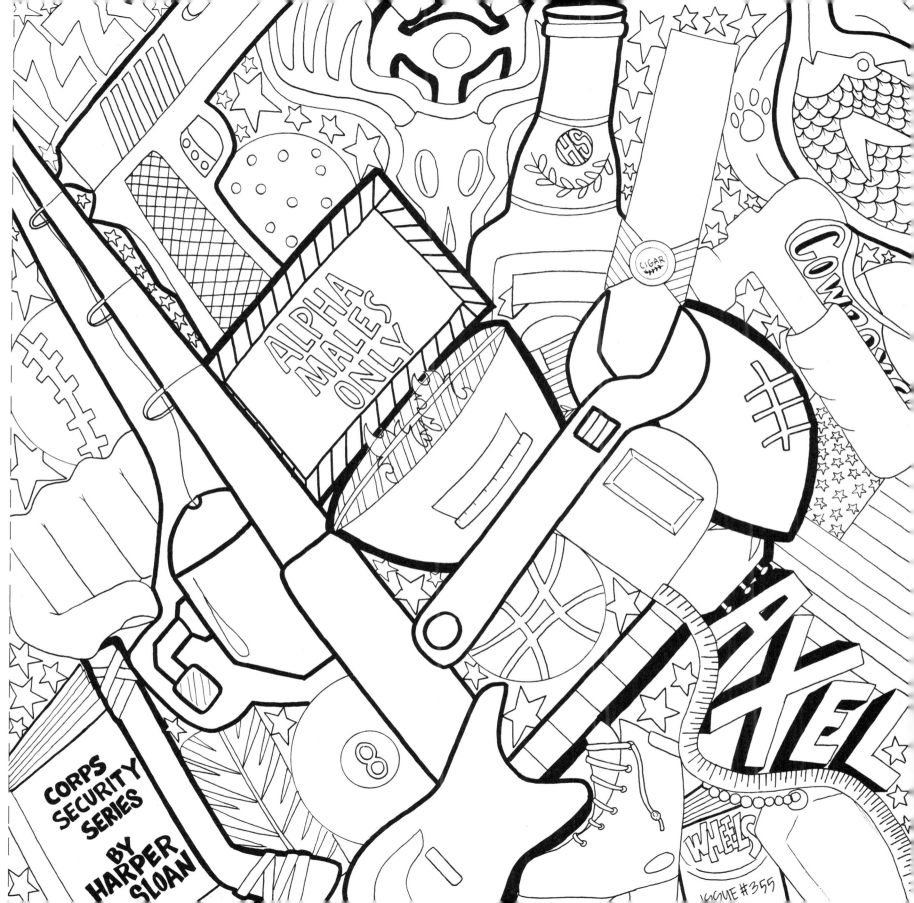

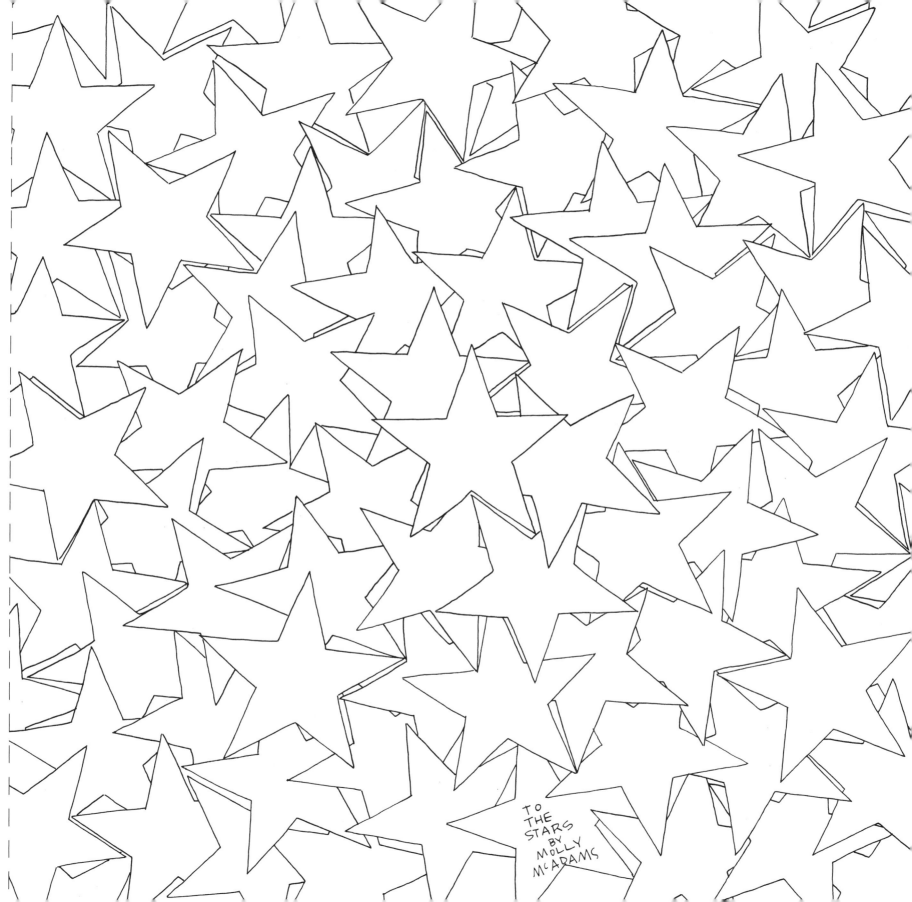

TO
THE
STARS
BY
MOLLY
MCADAMS

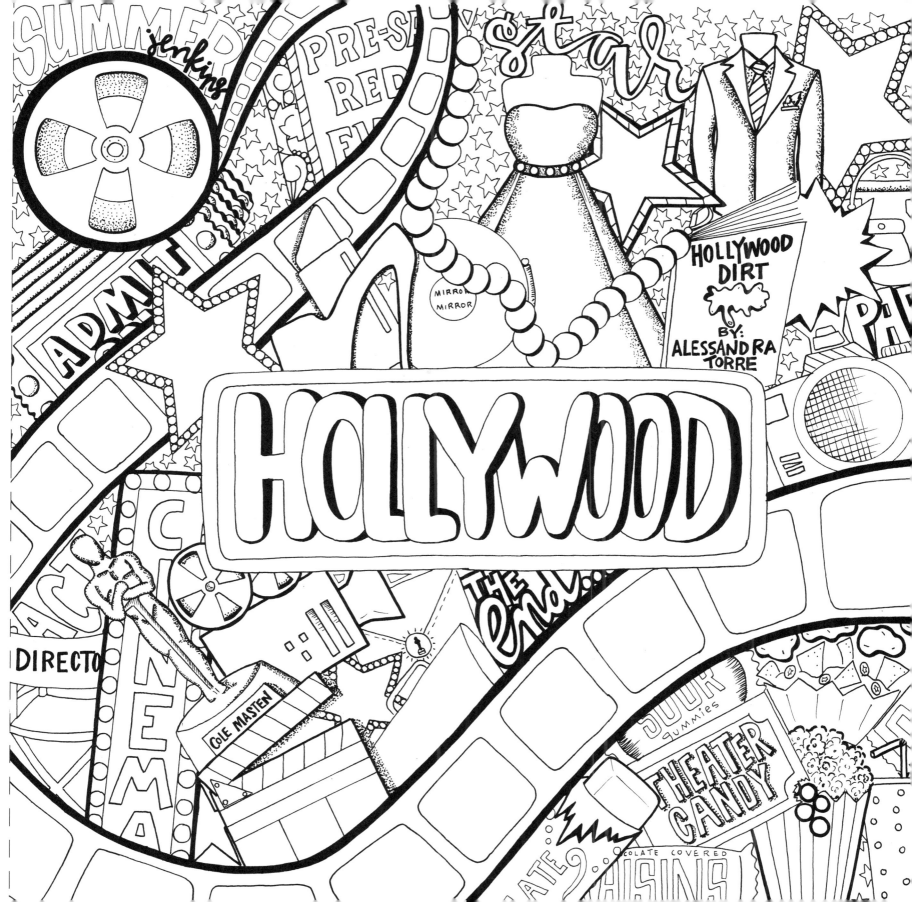

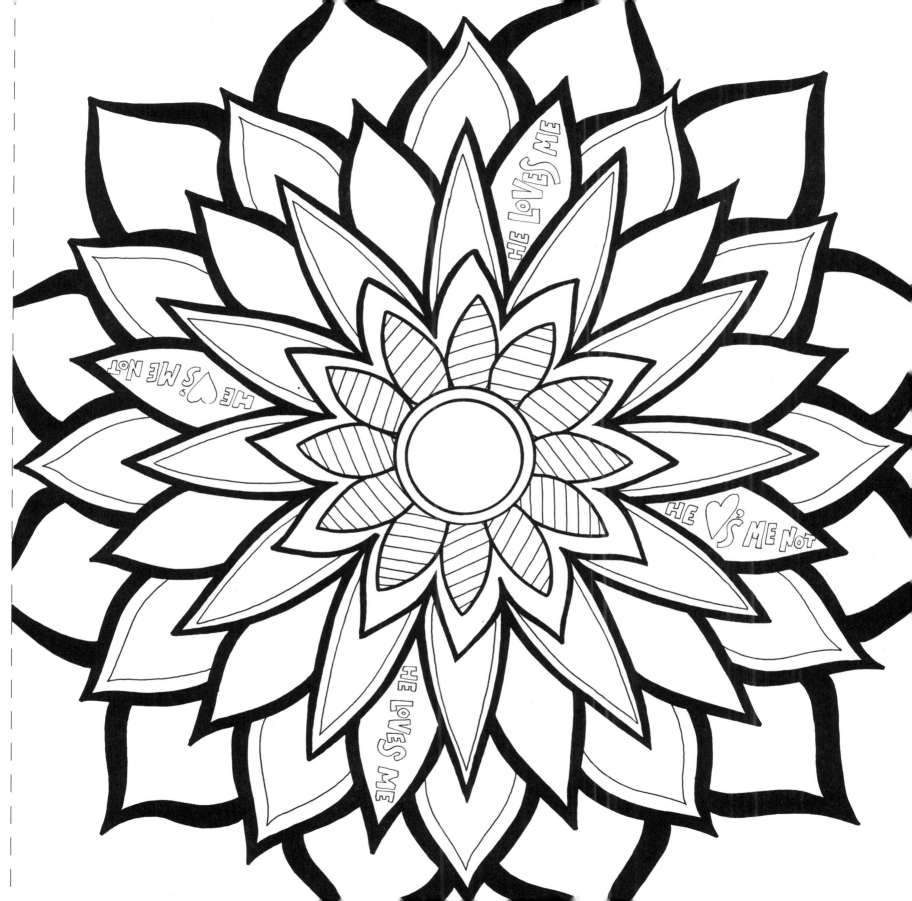

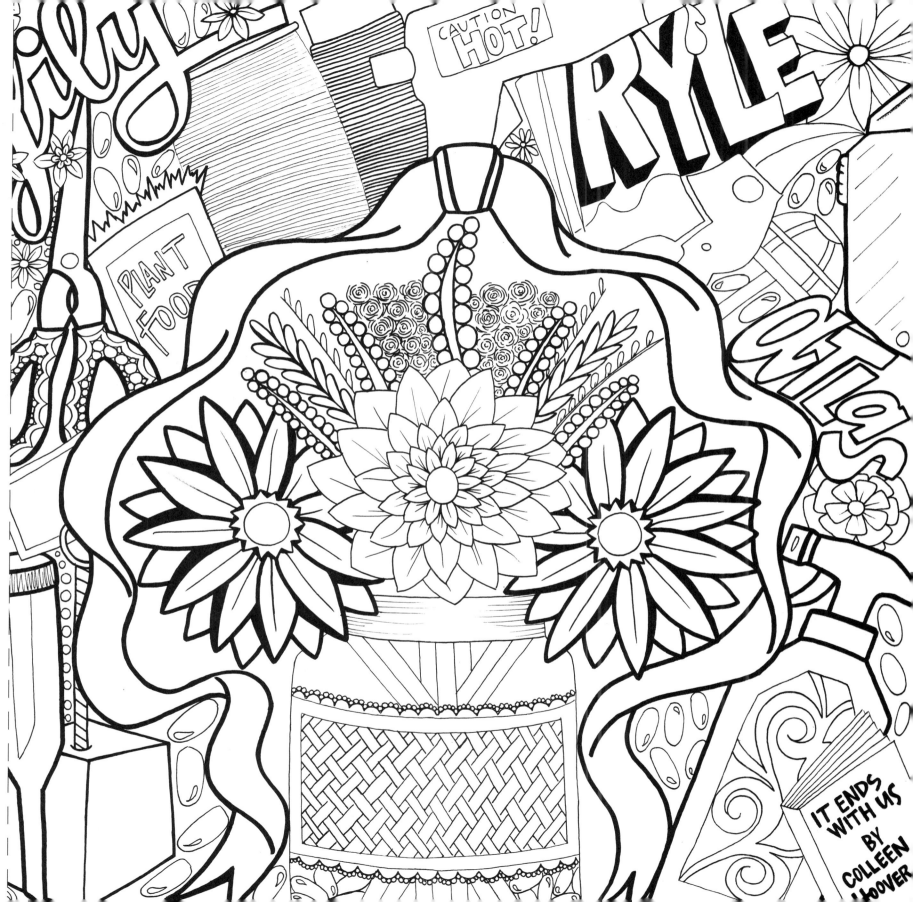

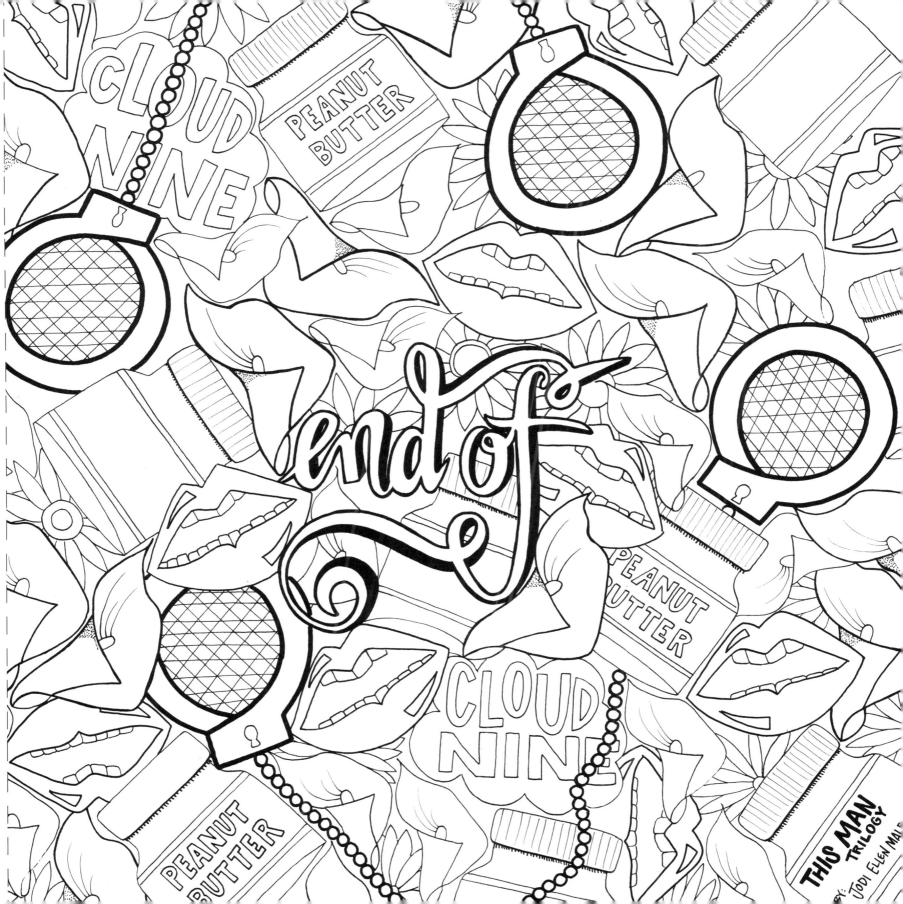

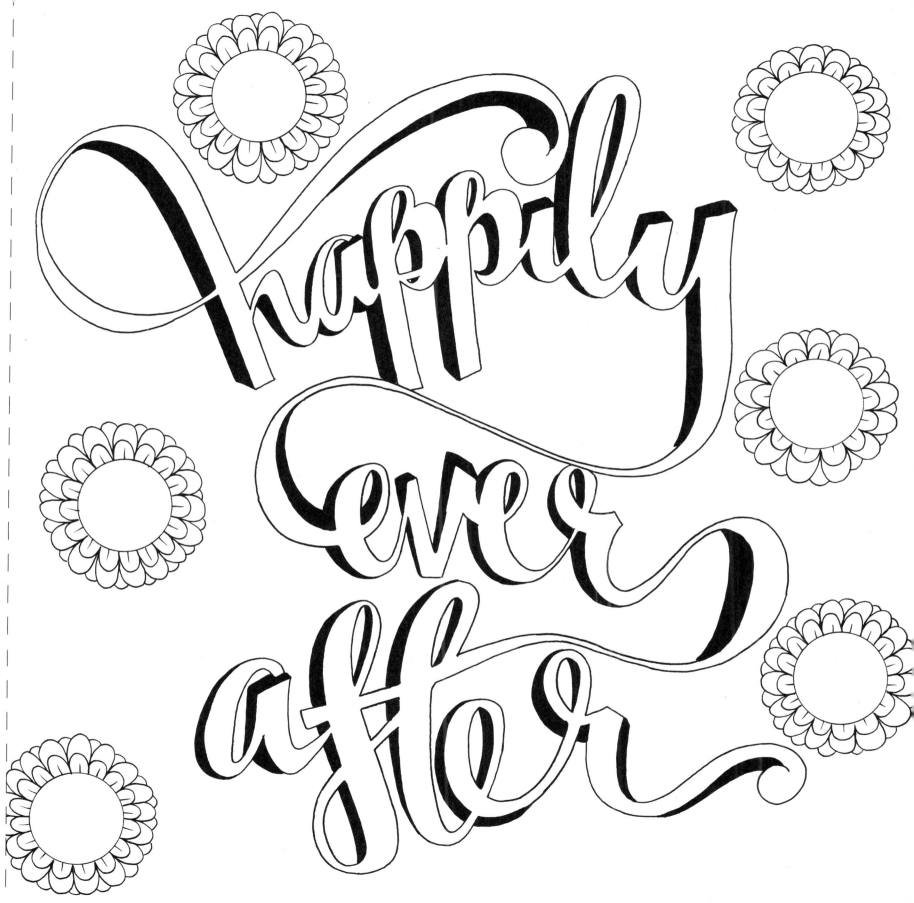

Acknowledgments

First and foremost I need to thank the people who made this book happen: Jenn Sterling, Madeline Sheehan, Maryse Black, Jenny Aspinall, Nicole Brady, Shayna Thompson, and most of all my mother, Mary Collie. Thank you for pushing me to share my love of reading in the form of a doodle with the world. If it weren't for them, I wouldn't be where I am now.

Also to Amy Tannenbaum, aka the best agent in the world, for not only giving me the push to do a coloring book but for keeping me sane. You're the best agent—ever.

To my fantastic team at Forever: Amy Pierpont, Jodi Rosoff, and Madeleine Colavita. I feel so lucky to be working with you.

To Colleen Hoover, who jump-started this for me. Thank you for your friendship, your encouragement, and being an all-around amazing person.

To my friends and family who have done nothing but support me. I love all of you, seriously. Big thank-yous to Gerald Collie, William Collie, Melody Lee, Michelle Magee, Stephanie Knight, Amanda Cantu, Lara Feldstein, Grant Brock, and anyone and everyone else who's helped me along during this process.

To Colleen Capone and Frances Villaverde, thank you for being my number-one fans, my number-one cheering section, and for your constant encouragement from the beginning.

To my Gal Friday, Melissa Panio-Petersen, for every bit of help throughout the years, for keeping things going while I was absent, and for jumping in to handle forms while I drew—thank you.

Big thanks to my biggest V-Dub supporters, Travis Tidwell and Lisa Funches. You're the MVPs.

Last—and most important—to the authors within this book: S. C. Stephens, Abbi Glines, Jodi Ellen Malpas, S. L. Jennings, Claire Contreras, K. A. Linde, Anna Todd, Tarryn Fisher, Amy Harmon, Mia Sheridan, Beth Ehemann, R. K. Lilley, Tara Sivec, Tiffany King, K. A. Tucker, Karina Halle, Molly McAdams, Jillian Dodd, K. Bromberg, Emma Chase, Katy Evans, Alessandra Torre, Helena Hunting, Harper Sloan, Leisa Rayven. Thank you, from the bottom of my heart, for allowing me to use your books as inspiration for this coloring book, and for my artwork in general. You guys are my rock stars, and without all of you, none of this would have been possible! (And thanks for not trying to toss me off a bridge for my constant messages and phone calls, haha!)